Your Assignment:
PHOTOGRAPHY

05·11·09

This book is dedicated to my students.
You have taught me as much
as I have taught you.
Thank you.

Douglas

Photo Developing Volume II

Your Assignment:
PHOTOGRAPHY

An Interactive Resource for
Students and Teachers of Photography

Douglas Holleley MFA PhD

CLARELLEN

C L A R E L L E N
116 Elmwood Avenue
Rochester NY 14611
www.clarellen.com

ISBN 978-0-9707138-7-2

TABLE OF CONTENTS

*Assignments are
shown in italics.*

Examine the practices and procedures employed by art museums and conceive a visual investigation based on an aspect of this research.

119 Related Assignment

Make a Wonder Cabinet.

120 **PART TWO: ON EVIDENCE**

Consider the nature and uses of photography in the construction of evidence.

121 *Take images made as evidence for one world-view, function as evidence for a different perspective.*

122 *Accept the malleability of meaning inherent in the photograph (especially the historical photograph) and use it to create your vision of the past.*

123 *Create a Digital Conspiracy.*

125 *Create a fictional event and then make an (un)real document.*

126 *Create a performance to be photographed with the intention that the finished product be the image of the event as much if not more than the performance itself.*

127 *Create a Narrative Tableaux.*

129 *Construct a new reality by combining material from a number of separate images into a new single image.*

130 *Create body types, both idealized and abnormal.*

131 *Create a new landscape.*

133 **PART THREE: ON WORDS AND IMAGES**

Devise a means to combine Words and Images in such a way that each equally participates in the generation of meaning.

INVITATION TO PARTICIPATE

This book, of necessity, represents the author's perspective and opinion. No doubt some readers will agree with some of the things said and disagree with others.

If this is the case, please contribute. Should you have a different perspective, a suggestion for similar or quite different assignments, then please contact me. Suggestions for the Bibliography are especially welcome.

The book is printed "on demand." Accordingly, it is a live document that can be altered, modified and expanded as material comes to hand. It is my intention to up-date the book annually.

Please send any comments or additions to the author. Ideally send an image or two as well to illustrate your point.* If your comment or assignment is selected for inclusion you will receive full credit for your contribution as well as a free copy of the book.

Address your comments to douglas@clarellen.com

* Image Submission Guidelines

Send maximum quality jpeg files. Size is 6x4 inches at 300ppi.
Also enclose a statement with the name and address of the photographer, the title of the image and a statement to the effect that
Clarellen has permission to reproduce the image in the book.

FOREWORD

 It was at a meeting of the American Association for the Advancement of Science, in 1931, that the scientist and philosopher Alfred Korzybski proposed that, "The map is not the territory." The essence of his statement posits the idea that any abstraction or representation is not the thing represented. I bring this thought along with me when considering a work such as Douglas Holleley's, *Your Assignment: PHOTOGRAPHY*. What then is the nature of the map that the work represents?

It clearly reveals a path through a series of problems or exercises that are intended to challenge one's understanding of the potentials of the medium. Too often photographic manuals have emphasized a myopic relationship with technique and not with the conceptual possibilities of image making. Holleley has placed an emphasis on the conceptual and by doing so created a resource of possibilities that through their exploration will reveal more than one might first assume. By extension you will come to recognize the cumulative effect that these exercises can have in developing ones visual vocabulary. In this process of "mapping" you will find Holleley to be an accomplished guide.

Nathan Lyons
Distinguished Professor Emeritus, SUNY
Founding Director Emeritus, Visual Studies Workshop

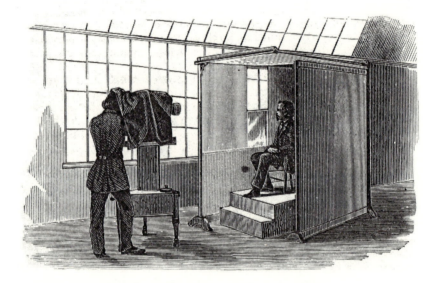

Above: Illustration from, Wilson's Cyclopædic Photography.
A Complete Hand-book of the Terms, Processes, Formulæ
and Appliances Available in Photography. Arranged in
Cyclopædic Form for Ready Reference.
Wilson, Edward L. New York: Edward L. Wilson, PhD, 1894.

INTRODUCTION

Although academic progression tends to be logical and linear, personal, artistic and intellectual development is not quite as predictable. The latter is best expressed in graphical form.

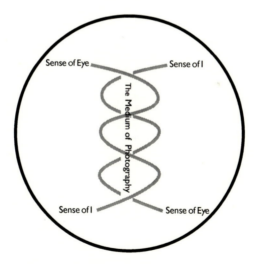

As the diagram suggests, the process of learning to use photography as a communicative and expressive medium may be depicted as set of interweaving spirals. One of these spirals, the Sense of Eye represents the quality of discriminating observation, necessary to produce an interesting and coherent

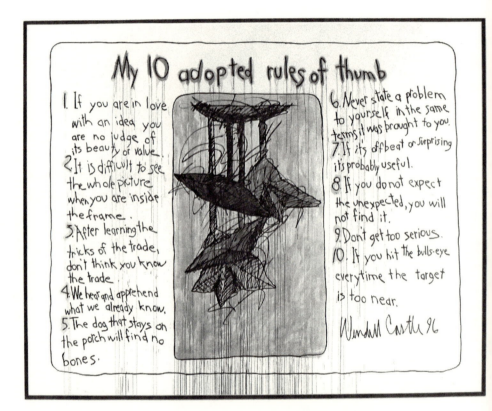

Above: My 10 Adopted Rules of Thumb *was conceived and illustrated in this print by Wendell Castle. Castle is a Kansas born, Rochester artist who creates elegant furniture that respects yet transcends function. From my perspective as the author of a book of assignments, I cannot help but breathe out a silent "ouch" when I read number 3. It is up to you, the reader, to realize that art education can sometimes be seen as a thousand needle-like pricks into the giant organic whole that is art practice. The moral is; keep your eyes on the whole, not the needles. (Original in color.)*

image. The other, the Sense of I, represents the more interiorized, but equally skilled qualities, that are concerned with affective and personal growth.

The third element in the equation is the medium of photography itself. This is simultaneously the goal because this is the medium we wish to master yet at the same time it is also the means by which the eye and the "I" can develop, grow, and even metamorphose. The final element in the drawing suggests that all of these variables are encompassed and directed within the circle of the mind.

Accordingly the book is structured to represent each of these interacting forces.

Chapter One is an overview of some of the more salient technical aspects of photography. This section addresses the medium by investigating its properties from the perspective of technical issues that are deeply, even fundamentally, embedded in almost all photographic processes and equipment. This examines photography's basic building blocks.

Chapter Two represents the Eye. These assignments and problems address the observational and perceptual aspects of the medium. They are designed to refine the skills of careful and patient vision, without which, meaningful and well observed images cannot be made.

Chapter Three addresses the "I" aspect of the equation. These assignments will assist in developing a sense of self, both at a personal level and with respect to the world at large.

Chapter Four represents the more conscious mind. This section is cognitive based and more academic in nature. The assignments are designed to promote a spirit of enquiry, a respect for historical precedent, and an embrace of theoretical analysis.

Finally, the book concludes with an Afterword that addresses issues of editing and presentation. It also contains a final assignment, and a Bibliography.

In conclusion, all of the above can be subsumed in what I term, the Master Assignment. It is this assignment that starts both the book and the quest.

A SHORT NOTE ON ASSIGNMENTS

To illustrate the key points I have employed the teaching strategy of "the assignment." However, there are many types of assignments and just as importantly, many ways of employing them. This can best be appreciated graphically.

Specific Assignment Open ended Assignment
Specific Response Expected Variable Response Tolerated

On one hand assignments can be very specific and just as importantly, so can the discussion and evaluation of the work generated by them. At the other end of the scale expectations can be set very broadly with minimal guidelines or restrictions and likewise the discussion about the results be equally unconcerned with the relevance of the response, but instead directed to what has actually been produced. In practical terms, the early years of study tend to adopt the first approach while in the senior years a more open approach usually prevails.

Thus, look at the assignments in this book as being somewhere in between these two extremes. They are employed as a device to clarify key concepts and suggest topics for verbal and visual debate rather than questions begging specific responses.

MASTER ASSIGNMENT

Show the World through Your Eyes

RATIONALE

The brevity of this request masks the fact that rather than a week long, or even semester long assignment, this is the task of an entire lifetime. Like most things that can be simply, if not easily expressed, this apparently innocent phrase conceals considerable complexity. To fully appreciate this it is helpful to carefully examine each of the key words.

TO SHOW:

Photographs can only show what something looks like, in a particular light, from a particular vantage point, at a particular moment in time. They cannot tell us anything, they cannot judge and it is debatable whether or not they can interpret. Certainly they cannot communicate the sensation of smell, sound or feel that we might experience while out in the world or the studio while we are making the images. The cyclopean automaton we call the camera can only show the appearance of that which was in front of our eyes at the moment of exposure.

The photographer does not have the luxury of either reflection or the ability to incorporate non-visual sensory impressions. A poet can be attracted by the appearance of a particular event, but at a later time, weave all of his or her other impressions, including smell, sound and taste into a finished poem. Additionally, with the benefit of time and hindsight, he or she can add to these contemporaneous impressions with memories of similar or contrasting events. In other words, things that were invisible at the time.

Thus the photographer's job is that much more difficult. Within the split second that the film or digital chip was allowed to glimpse a coherent pattern of light, the photograph must show not only the subject, but also imply, if not explain, what it was about it that attracted you at the instant of exposure by virtue of its appearance alone.[1]

It is a sobering thought to realize how much photography deals only with appearances. The word implies superficiality. This attribute has attracted the criticism of thinkers like Susan Sontag who mercilessly derided photography on the basis that judgments/images/photographs based on appearance alone are somehow intrinsically inferior.[2] However, it is of interest to stop and think just how much our life is ruled by appearance(s), and just how powerful (for both good and bad) this can be.

For example: how many people base the choice of their life partner on how she or he looks? How much of the maternal instinct is based not on some deep, mystical, invisible bond but on the fact that an infant, with its miniaturized, soft, and cuddly features engenders a protective response? How many wars have been justified because the enemy looks different?

THE WORLD

What you choose to photograph and the way you choose to photograph it, is entirely up to you. Within the constraints of time, budget and opportunity, you can choose to photograph any-thing in any-way. You can, and no doubt will try from time to time, to photograph everything. However, this is literally impossible. Sooner or later you will have to decide what will be the manageable chunk of that awesomely complex three-dimensional world to investigate. The point is that ultimately, your area of concern will be a choice that you, and only you can make.

1. *Admittedly there are ways of working with your images after the event to suggest further levels of meaning and complexity. For example, post photographing processes such as hand-coloring, photo-montage and/or the addition of some sort of text are just a few techniques that can add extra meaning and context. However, most photographers enjoy the challenge of making the record of that initial act of direct visual perception we call the photograph, as resonant and as self-explanatory as possible.*

2. *Sontag, Susan.* On Photography. *New York, NY: Farrar, Strauss and Giroux, 1978.*

YOUR EYES

This is the most deceptively simple concept. I can almost hear the reader say, "It is only through my eyes that I must, by definition, see." However, I ask you to pause for a moment and really think about who you are referring to when you use the pronoun "I." Is it the "I" that chats and laughs with your friends in the cafeteria, the "I" that speaks to your parents on the telephone, the "I" that speaks to your boyfriend or girlfriend when you are alone together? How many "I's" (eyes?) do we possess? What is the real nature of our identity?[3]

This is an increasingly complex issue. Consider just some of the variables. We can now engage life coaches and other folk who promise self improvement. Cloning technology is a reality and genetic manipulation of humans is just around the corner. We can manipulate our appearance with plastic surgery and even change our most basic given, our gender.

All these things have combined to alter the issue and nature of identity in profound ways. This has extended to the point where the fastest growing crime in the new millennium is identity theft.

More positively yet no less complicating, in a more pluralistic global society, cultural identity and religious belief have become, more than ever, issues to consider with respect to one's sense of self. Nevertheless, as students of photography, at some stage we will have to come to some position on this issue for if indeed we are to show the world through our eyes, then the concomitant responsibility is to determine with some precision, just who or what, is this "I" behind the eyes.

3. It is an interesting and sometimes scary task to look at oneself and one's behavior and examine its origin. How much of it is truly yours? Examine your gestures and characteristic expressions, your taste in clothes, and other personal habits. Try be honest about where, how, when, and in what circumstances, you "picked up" these things. How many of them are helpful? How many are harmless? How many are the antithesis of what you might like to be? (It is surprising how many "bad" things we adopt from people who we don't even like, for a whole variety of reasons, almost always due to some process of reactive identification.) Imagine what it might be like if you could shed these acquired characteristics one at a time, much like peeling away the layers of an onion. How much would be left?

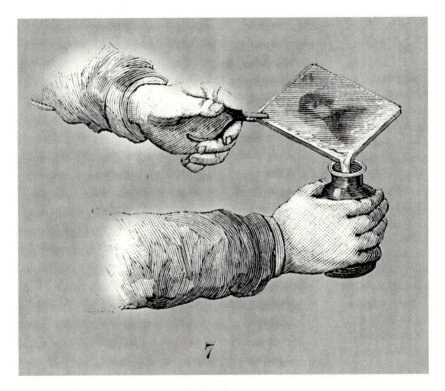

Above: A daguerreotype being "fixed" by sodium hyposulphate. Perhaps due to being Australian by birth I sometimes wonder whether one of the great unintended consequences of the digital revolution will be an entire generation of photographers (of legal age of course) who do not know how to pour wine from a glass back into a bottle! (A survival skill down under to be sure.) Image courtesy of George Eastman House, Rochester, NY.

CHAPTER ONE: EXPLORING THE MEDIUM

ASSIGNMENTS BASED ON TECHNICAL OR PROCESS ISSUES

INTRODUCTION

From an educator's perspective, it is an interesting curriculum problem to devise a basic photography course. For the past few decades such a course usually involves using a 35mm camera and black and white film stock. When you consider the entire history of the medium this is actually a very strange choice. Both 35mm cameras and film are relatively new additions to the field and are an odd mix of relatively poor print quality and optical/mechanical sophistication. Why not start with the Daguerreotype or Calotype? Why not learn basic principles with the most basic and simple camera of all, the 4x5?

The point I am making is that there are other, even more basic ways to make images, which can produce beautiful, large-scale prints and generate a deep appreciation for the principles and materials of photography.

This chapter examines alternative ways to approach the basic building blocks of the medium. Although these processes look deceptively simple, if undertaken seriously and joyously, they can produce work of great beauty and interest. Just as importantly, they provide insights into the medium at a very fundamental level, which can then be transferred to more sophisticated technical processes.

Above: One does not even need actual objects to make a photogram. In this case, after being softened in warm water, a sheet of photo-paper was rolled up and tied with leather thong. When wrapped it formed a rounded cube-shaped bundle about 10 inches in size. This bundle was then exposed to light from an enlarger. In some instances light fell directly on the emulsion to create the rich blacks evident in the print. In other cases, the folds of paper with-held light to form the various shades of gray and the highlights. After exposure the bundle was unwrapped and the again-flat paper was developed normally in the darkroom. The finished print is 16x20 inches.

The Flight. *1991. Image by the author.*

ASSIGNMENT

Employing first principles, experiment with the physical and formal qualities of your medium.

RATIONALE

The experimental approach to photography, particularly at the fundamental level of first principles, was initiated at the Bauhaus in Germany in the 1930's. After the Nazi's closed the school in the years leading up to the Second World War, many of the faculty emigrated to the United States and perpetuated and refined these principles at the Institute of Design in Chicago. Among this distinguished faculty was the Institute's first teacher of photography, Laszlo Moholy Nagy[4] who devised deceptively simple open-ended experiments so that students might understand the basic processes and materials of the medium.

4. See the San Francisco Museum of Modern Art website, http://classes.asn. csus.edu/vail/art101/ lecture%20notes/12. bauhaus.htm

THE ANALOG PHOTOGRAM

Probably the most famous of these was the photogram. Although examples of photograms exist from the very beginning of photography (Sir John Herschel made notable images in this vein as early as 1840) Moholy Nagy greatly expanded this genre by applying his ruthless modernist sensibility to a search for form for form's sake coupled with a deep and abiding appreciation of the role of light in the medium of photography.

A tireless experimenter, Moholy Nagy and his students made hundreds of photograms, often making the experiment more complex by both using moving light sources and/or moving the objects during the exposure.

As old as this experiment is, much can still be learned. It is well worth spending a day or two (or more) enjoying the simplicity and elegance of this process. One of the great joys is to appreciate just how beautiful photographic paper really is when it is not exposed through a film matrix. When the paper images directly from life there is no film grain or compres-

sion of tonal values as the paper tries to render the negative. The black caused by a saturating, un-modulated light source is astonishing in its depth and richness. Similarly the modulation of tone as the paper responds to greater or lesser amounts of light can produce ultra smooth tonal variations almost im-possible to achieve when printing from (or more correctly, through) a negative.

The simplest way to make a photogram is to place a piece of photographic paper under the enlarger, place objects on this paper and turn on the enlarger long enough to get a rich black. This however, is a very basic approach. It is important to remember that a little preparation goes a long way—as does flexible, open-ended thinking.

The following are a few suggestions that may prompt you to consider a variety of creative responses to this experi-ment:

1. Utilize items of personal significance.
2. Choose items that have intrinsically light-modulating qualities such as cloth, glass, or even images cut from magazines or other sources.
3. Experiment with differing levels of sharpness and focus by placing some items directly on the paper and suspend some in the air over the paper.
4. Investigate what happens when the photographic paper is not simply laid flat but curved, or even folded into other configurations while being exposed to light.
5. Move the objects during the exposure.
6. Experiment with moving light sources. Try using a flashlight, a hand-held strobe, or even a candle.
7. Introduce type into the image. This can be done in a variety of ways:
 a. Laying down cut or torn strips of paper printed on your computer on either transparent or translucent substrates.
 b. Use found printed type.
 c. Use stencils.

8. Place the paper in water and (directly) image the ripples and reflections with a strobe.
9. On the chemistry side try using a paintbrush to apply the developer and/or fixer or use only stop bath to fix the print. If you try the latter, observe how black and white paper can produce a variety of colors.
10. Engrave images on translucent plastic and use these as a matrix to through which to project light. (Cliché-verre.)

The beauty of the photogram exercise is that you engage with the basic building blocks of the analog photographic process. One can play or experiment with light, photo-paper and chemistry in a direct manner.

Right: Another photo-gram created by rolling up a blank sheet of photo-paper. Image by the author. Light Dancer. *1991.*

THE DIGITAL PHOTOGRAM—DIRECT SCANNING

Regrettably there is no way one can get a hands-on experience with pixels in the same way you can slosh around with photopaper, developer and fixer. However, there is one process that has striking similarities to the photogram from the perspective of simplicity, indexical quality and scale. This is the use of a flatbed scanner to make first generation images.

Customarily the flatbed scanner is used to digitize a photographic negative or print. However, using a flat bed scanner to make a first generation image can produce a result that has many of the same qualities of the photogram, both in terms of permitting access to the qualities of the medium at the level of first principles, and producing an image of an object by virtue of proximity, if not direct contact. This occurs both as a function of the large scale of the scanner itself and its size relative to the object being imaged.

The image capturing area of even a small letter size scanner approximates the descriptive power of an 8″x10″ large format camera. In either conventional or digital photography, when it comes to negative/chip size, bigger is almost always better. This is most certainly the case with direct scanner imaging. The only real disadvantage of this form of image capture is that the size of the objects you can image is limited by the size of the bed of the scanner.

Opposite: This image was made by cutting up, crumpling and drawing on, an anatomy text book from the nineteenth century. Books of this vintage are excellent candidates for re-imaging. Firstly, they are well and truly in the public domain and can be used with no fear of infringing copyright. Secondly, they are printed without the annoying and destructive screening that occurs when images are printed on an offset press. Offset images when scanned, usually and irritatingly, form distracting moire patterns. More importantly, the moire emphasizes the fact that you are using images that most likely are not your own.

In saying this I am mindful of the fact that re-imaging existing images is, if done carefully and respectfully, a legitimate form of comment. It could well be argued that if we are to be bombarded daily by a flood of images designed to make us usually want to buy or possess some-thing, that it is only fair that we retaliate by commenting visually in our art practice. (See Buzz Spector's work.) From the author's book, Love Song. *Woodford, NSW: Rockcorry, 1995.*

Most scanners have a surface area about 8.5″x11″ but tabloid scanners are also available. Even more exciting, but incredibly expensive, are new commercial flat bed scanners that can scan objects up to 6 feet.

Irrespective, all direct scanning produces a transcription of reality encoded completely in digital terms at a ratio of 1:1. This is far superior, and quite different to either an enlarged analog print or even a high-resolution digital image. Like contact printing from an 8″x10″ negative, the exact correspondence that exists between the scale of the original matrix and the size of the final print eliminates the destructive effects of enlargement.

Scanning is analogous to low level aerial photography. As the scanner bar moves across the subject, depending on the resolution, up to thousands of tiny micro-photographs, each a pixel in size, are made and subsequently assembled in order, on the page. As such the image does not have a single vanishing point as does a photograph made with a lens. This flattened perspective is particular to scanning and cannot be achieved (as far as I know) by using any other device.

The basic practical rule of scanning objects is that the object is modeled by its distance from the glass. In order to get a white scan using a white piece of paper, place the paper flat on the glass. Lifting the paper an inch or so off the glass will produce a middle gray. Removing the paper entirely, with the scanner lid left open in a darkened room will result in a black scan. Thus the tonal range of the image will reflect the three dimensional qualities of the original object as if illuminated from the front. Those parts of the object closest to the glass will be rendered lighter than those farther away.

Opposite: Another example of re-imaging a book. In this case the book was cut up with a bandsaw, twisted around its axis, and then laid on the scanner bed. Thus we have a "straight" digital image of a manipulated object. This was the author's first ever digital image. It is still a favorite, I have used it in many books and many people have said they really like it. To this day however, I still have not been able to sell one print! Interactive Reading. *1993. (Original in color.)*

Suggestions for direct scanning are similar to the photogram.

1. Utilize items of personal significance.
2. Experiment with differing levels of sharpness and focus by placing some items directly on the platen and others suspended in the air.
3. Move the objects during the scan.
4. Experiment with external light sources such as a photo-flood or similar.
5. Introduce text into the image. This can be done during the scanning process or by using the Type Tool in Photoshop.

While attempting this process it is interesting to consider that the word "scan" is one of the few words in the English language that has two, diametrically-opposed, meanings. Scan can mean either to scrutinize minutely or alternatively, to glance at hastily. The first definition probably embodies a more helpful attitude than the second.

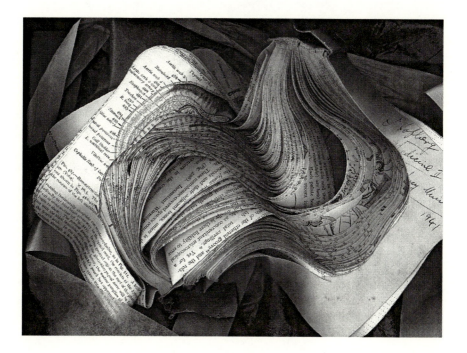

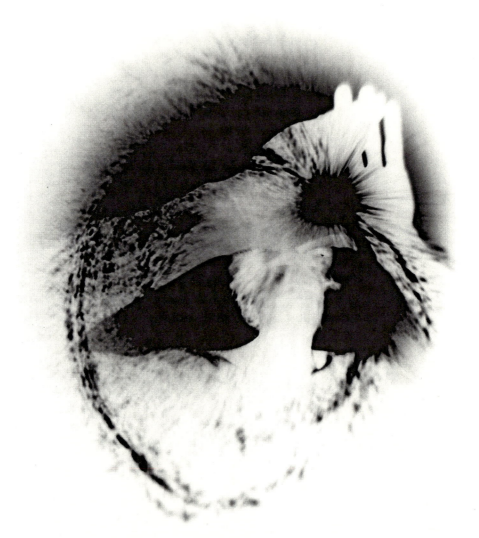

The pinhole camera was on the ground facing upward with a sheet of 16"x20" paper in it. This was about a 5 minute exposure with about a 3 second exposure of the sun coming through a pinhole made between my fingers. It took a lot of practice to get the solar flare just right. After the three seconds of the sun coming through, I closed up my fingers for the rest of the exposure. Image by Eric Renner. Self. 16"x20" pinhole photograph, 1977. From the Collection, National Gallery of Canada.

THE PINHOLE CAMERA

One of the striking things about the previous two experiments is that images are being made without the benefit of a lens. It is therefore helpful to consider applying the same sensibility of first principles to how lens vision, still the main agent of imaging in photography, actually works. The simplest and best method is to construct a pinhole camera. These are cheap to construct, fun to use, and provide insight into photographic principles that are difficult to achieve in any other way.

The basic principle of the pinhole camera is that light travels in straight lines.

Right: A pinhole lens functions as a single "gate" allowing points of light from each part of the subject to be projected onto a picture plane to form a resolved image.

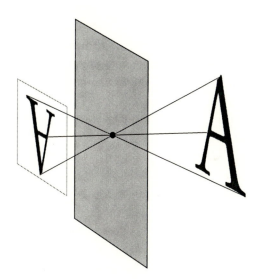

To make a pinhole camera one simply needs to make a small aperture in a thin sheet of metal. Cut open a soda can with scissors and then cut a small piece, about an inch square out of the metal. Using a small needle, twist it through the middle of the square until it is about a quarter of an inch up the shaft. Sand the burr off the pinhole either with 600 grit emery paper or a fine nail file. The goal is to get a clean hole about half a millimeter in diameter (0.0127″).

Cut a hole about 0.5″ (2cm) in diameter in a box of choice. Mount this metal square so that the pinhole can allow light to pass through and project an image on the back of the box. Paint the inside of the box matt black to minimize reflections. This pinhole size is ideal for a box around 3 inches deep. It will give you a wide-angle view of the world encompassing about 140 degrees. The aperture of the pinhole is very small so your exposures will be overly long if you use a box that is too deep.

To make the image; under safe light place a piece of photo-paper inside the box. Place a suitably opaque piece of tape over the pinhole and then take the camera out into the world. As a starting point try pulling the tape off the pinhole for around 30 seconds in daylight. When you think you are done, place the tape back on the pinhole and return to the darkroom and process the image in regular photo-paper developer. When developed, the photo-paper will be a negative image. Then use this paper negative to make a contact print on a substrate of your choice.

In general terms consider the following issues when using a pinhole camera:

1. Because of the large negative size, focal lengths tend to be short. Thus, pinhole cameras usually render an ultra wide view of the world. Get close to your subject.

2. Experiment with boxes of different sizes and shapes. Some of the most interesting pinhole images I have ever seen were made by using the spherical canister of a 1960's Hoover Constellation vacuum cleaner! This permitted the paper to be wrapped around the inside of the container rather than simply be a flat plane for the pinhole to project upon. In many ways this replicated the inside of the eye, which is not flat, but instead, hemi-spherical in shape.

3. Experiment with anamorphic projections by placing the paper inside the box at an angle to the "lens."

4. Make a camera that has more than one pinhole.

NOTE: Readers with a scientific bent may wish to actually calculate the aperture expressed as an "f-number" by applying the following formula:

f = Distance from the "lens" to the film plane divided by the diameter of the aperture.

Therefore, if your box is 3 inches deep, and your pinhole is about 0.5mm or 0.019685 of an inch, then your effective aperture will be 3 ÷ 0.019685. This produces a value of approximately f152.

Choosing a box 6 inches deep will give you an effective aperture of around f304.

5. If you want your images to have a paper texture use fiber-based paper. If you wish to obtain a smoother tonal response with more contrast use RC paper instead. Using mat paper will minimize internal reflections.

6. Instead of paper try using ortho film. If developed in dilute Dektol developer (around 1:10) continuous tones can be obtained. Such negatives can produce very high quality images.

7. When printing the paper negative experiment with both placing the paper negative in direct contact with the substrate under glass and also simply laying the paper negative loosely on the substrate.

Above: All the holes on a 19 pinhole camera were opened at the same time exposing a piece of 9 inch square film. Exposure time was about 20 seconds. The film plate cardboard was somewhat warped so that the focal length of the center of the image was increased. Image by Eric Renner. John Wood. 9" diameter, 19 hole pinhole photograph, 1970.

PROCESS BASED APPROACHES

INTRODUCTION

Process based methodologies, often described as non-silver processes, are those where the making becomes part of the telling. In other words, the author of the images permits, even encourages, the process of imaging to participate in an active way in the outcome of the finished statement. This can extend to permit accident and serendipity to play their part in the final expression of the work. Some of the processes permit fine control of the finished art object while others can be so cantankerous as to inevitably change any pre-visualized idea of what the final object should look like or communicate.

This way of working doesn't suit everyone. It is particularly appropriate for those individuals who like materiality and tactility in their finished work and enjoy the physical act of making. It is less appropriate if your perspective is more intellectually based and/or the veracity of the finished photograph is an important aspect of your work. Process based investigations are a strange mix—they can be often very demanding technically compared with conventional analog or digital photography yet their relationship to photographic truth or more correctly verisimilitude, more loose and elliptical. The tight integration of method and outcome and the need to surrender to the vagaries of the process itself will inevitably cause some tension if you have very clear ideas on what a photograph is or should look like.

It is not the role of this book to give detailed instructions on each and every process. There are many excellent textbooks on this subject. A reader interested in this way of proceeding is encouraged to seek them out. However, there are classes and sub-classes of working methods and the following list will assist the reader in determining what is appropriate for his or her needs if this area of investigation seems worth exploring.

NON-SILVER PROCESSES

TRANSFER PROCESSES

These are processes where images are transferred from one substrate to another for creative or expressive effect.

1. Xerox transfer.
2. Polaroid transfer.
3. Emulsion transfer.
4. Rubbings from magazines.
5. Gel medium lifts.
6. Iron-on transfer material.

NON-SILVER PRINTMAKING PROCESSES

1. Cyanotype.
2. Photo etching.
3. Van Dyke brown prints.
4. Gum bichromate prints.
5. Platinum and palladium prints.

POST PROCESSING OF SILVER PRINTS

1. Toning of Conventional Silver Based Photo-paper.
2. Hand coloring.

OFFICE MACHINE PROCESSES

1. Use of photocopiers.
2. Use of facsimile machines.

ALTERNATIVE MEANS OF IMAGING

1. Cliché verre.
2. Imaging via agency of heat.
3. Imaging via agency of pressure.

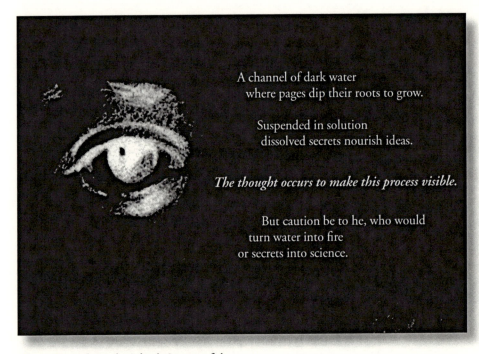

A channel of dark water
where pages dip their roots to grow.

Suspended in solution
dissolved secrets nourish ideas.

The thought occurs to make this process visible.

But caution be to he, who would
turn water into fire
or secrets into science.

Above: From the author's book, Secrets of the
Spread. *Rochester, NY: Clarellen, 2005.*

CHAPTER TWO: THE EYE

ASSIGNMENTS BASED ON PERCEPTUAL AND/OR OBSERVATIONAL ISSUES

INTRODUCTION

The first part of this chapter addresses the observation and recording of light and color. There are a series of assignments which directly ask the reader to consider the fact that the camera does not record objects and things, but instead, the patterns of light reflected by, or transmitted through, them.

The second part of the chapter acknowledges that these patterns of light are seen in a space/time continuum. Accordingly there are a number of assignments that direct the reader to make this fact conscious, and incorporate it into, the subject matter of the image.

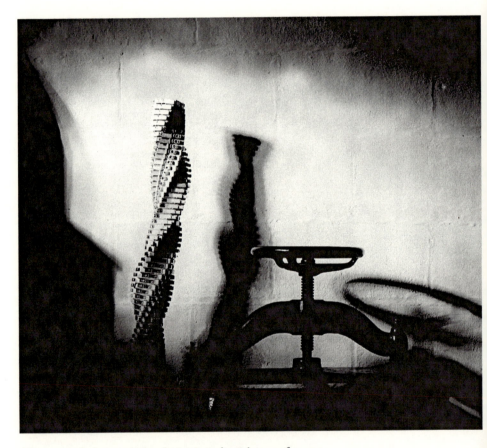

This image depicts a spiral sculpture I made with just a few of my empty Epson 2200 cartridges. Next to them is my book-press. The real subject however, is the pattern of light. Image by the author. Basement Light. *2008.*

PART I: LIGHT AND COLOR

ASSIGNMENT

Make the trace of the patterns of light that constitute a photograph, the subject of your image.

Paradox and illusion,
not objects and things,
are the photographers tools of trade.

RATIONALE

It is essential to differentiate between the objects pictured in the photograph and the subject of the photograph. Although on many occasions these can be one and the same thing, this is not always the case. One of the most wonderful things about using photography in an expressive manner is to capitalize on this disjunction. However, it is a difficult thing to address because we have been taught to look at photographs in a predetermined manner.[1]

1. The following argument is excerpted from the author's book, Digital Book Design and Publishing. *Rochester, NY: Clarellen, 2001.*

Probably the first experience you had reading photographs was as a child. You were given a book with an illustration on one page, and on the facing page there was most likely a single word. This word would usually be set in large, legible type. The function of this book was to teach you, the young child, how to read.

The image functioned as a device to help you decode the collection of letters on the page. There was no reward for appreciating this image, but parental accolade followed every instance when it seemed you were able to read the word. In fact the sooner you could read it without reference to the picture, the more you were encouraged. That strange little collection of signs had a meaning that transcended the particular image that was being observed. A picture of a curled-up sleeping

hound, a poodle dressed in circus regalia jumping through a hoop, a collie, a retriever, a working sheep dog, all could be subsumed under the label "dog." Past a certain point your skill improved to the point where the image need only be barely looked at. A glance was sufficient, once you learned the rules of the game. You were learning to read.

But more importantly, other things were also being learned. You were not just learning to read words; you were learning how to read images.

You learned that:

- images are less important than words.
- images can be looked at, and comprehended, quickly.
- to understand an image it is sufficient to identify the objects within it.

You learn these things because it is necessary to be able to generalize when dealing with written content. For example any word will (more or less) mean the same thing no matter what its image is on the page. Thus, desktop, *desktop* and desktop, all refer to the same concept and mean much the same thing, even though different typefaces actually change the physical appearance of the word. The ability to see through these variations in visual appearance is a cognitive imperative. If we could not do this it would mean that each time we picked up a book that was set in a different typeface, we would have to learn to read all over again.

The drawback is that we learn that a corresponding phenomenon can occur when looking at visual imagery. But visual imagery in general, and photography in particular, cannot be read in the same manner. More correctly, it can be read in this manner, but to do so runs the risk of using the medium to function simply as a surrogate for the objects pictured therein. In other words we learn to look at photographs as if they were an inventory of things. The photographs thus become a kind of shopping list of objects that can be identified and classified.

However, photographs do not directly re-present a prior reality in surrogate form. They show instead the appearance of these things from a particular viewpoint, at a particular time, through the agency of light.

The importance of light is reflected in everyday speech. How many times do we hear people say that a person, place or thing was presented in a good or bad light? That circumstances reflected well on someone? All these sayings reveal an almost intuitive appreciation of the function of light, which is no more or no less than to see. No matter how much it seems you are showing trees, bodies, rocks or water in your photographs, you are not. What you through the camera are seeing are patterns of light as projected by a lens on a two dimensional surface. Those trees, bodies and rocks do not and cannot directly impress themselves on the sensitive surface of the film or digital chip. Only the light reflected off these objects is recorded. If there is no light, there is no image. The corollary is that the pattern of light so formed is the content of your photographs.

This is the crucial aspect of photography. Until this is truly understood your images and how you perceive them will be rooted more in what you know about your subject matter rather than what you show about your subject matter.

METHOD

Try these simple exercises:

1. Photograph patterns of light.
2. Make the shape of a shadow the subject of the image.
3. If using a camera that permits this, use the aperture preview button on your camera to view the scene at the working aperture. If you press it quickly the scene will simply look darker. However, if you slowly press the button so the aperture progressively contracts you can then see more clearly the event rendered as patterns of light.

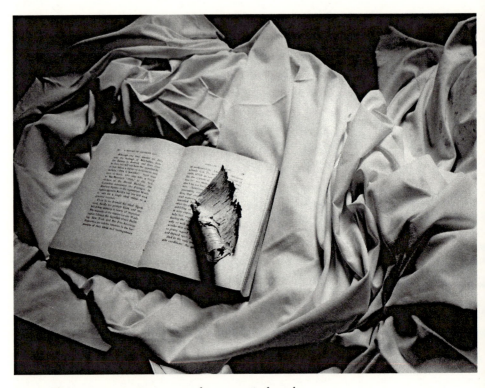

*In every home, at some stage, in some place, a magical patch
of light will manifest itself. When it does, carpe dium.
Image by the author from the book,* Paper Birch. *2004.
(Original in color.)*

ASSIGNMENT

**When photographing, consider carefully
the nature and quality of the light you choose.**

In particular:

1. While Observing Light
2. When Creating a Lighting set-up

1. Observing Light

Within every house or apartment, at some stage during the day, there will exist a place wherein the light is magical. Thus be patient and wait for this light to manifest itself. When it reveals itself, either be ready and make the picture, or take note of the time so that the next day you are ready and waiting. A very real benefit of this strategy is that you will train your eyes more quickly than if you attempt to simply rush in and try to create artificial light yourself. Having a tangible reality to compare with the images you make will do far more to refine your sense of observation and sensitivity to light than simply turning on a switch.

If you do this, then when you do use artificial light, you will do so with a heightened sensibility rather than bringing to the table an often-misguided sense of seeking answers through technique alone. The greatest technique, and the one that has the most effect on the appearance and quality of your images, is the quality of your attention span and your sensitivity to light. This will produce better results than any single other means.

2. Davis, Phil. *Photography. Dubuque, Iowa: Wm. C. Brown Publishers, 1990.*

Phil Davis[2] in his textbook *Photography* has given this strategy a name. He calls it *Selected Light.* This is both a great term and a great idea as it emphasizes the very real distinction between available light (usually meaning the light that is there at the time) and the careful consideration and selection of the light that is, or will be, available.

2. When Creating a Lighting Set-up

The basic principle is that the softness or otherwise of the light is determined by the size of the light source relative to the object being photographed. For example, if photographing a person, a light source such as that from a large softbox will produce a very soft effect.

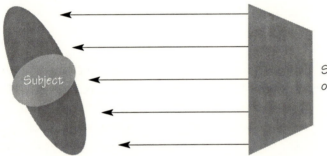

Softbox
or light from a window

This is an overhead view of a simple softbox setup. Observe how when the light source is large, the light is evenly distributed over the subject. In contrast, a small photoflood or unshielded strobe will produce a very different effect.

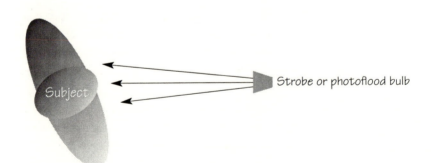

Strobe or photoflood bulb

Notice how the light from the smaller source is more focussed and direct. This results in a very contrasty image in comparison with the large diffused light emanating from the softbox.

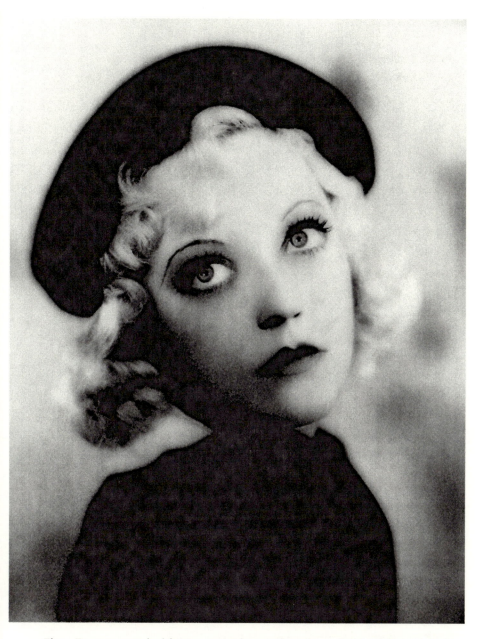

Elmer Fry was a noted celebrity portrait photographer who worked in Hollywood during the 1930's. He photographed many well known celebrities including Errol Flynn, Betty Davis and Delores del Rio. His portrait of Edward G. Robinson was the basis of a postage stamp featuring this actor.. His photographs demonstrate his profound mastery of lighting. Image of Marion Davis *by Elmer Fry 1899-1944, Hollywood c. 1930.*

EXERCISE

**Create a simple setup to enlarge the size of the
light source.**

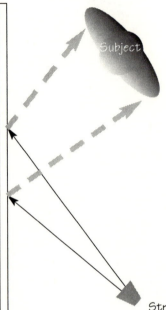

Subject

Strobe or photoflood bulb

White wall or large
sheet of foamcore

Softboxes and light diffusing panels are often used to effec-
tively increase the size of the light source. These are not al-
ways on hand and are also expensive to purchase. A simple
and inexpensive way to achieve the same effect is to bounce
the light source off a reflective surface. Camera mounted
strobes often take advantage of this fact and are bounced off
the ceiling. The extra distance the light must travel to reach
the subject and the scattering that occurs when the light hits
the reflecting wall, combine to give a soft beautiful light. As
with the previous two drawings, we are looking at the setup
from overhead.

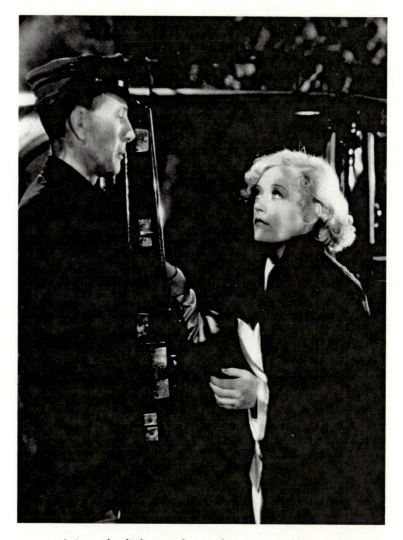

As is usual, a little research goes a long way. In addition to looking at the work of still photographers, also consider studying the work of cinema-photographers. These folk exhibit lighting skills of a very high level. Observe just how many light sources there are in this image. Look at the modulation on the faces and the carefully placed spotlight illuminating the hair of the actress. The author found this image, and the one on the previous spread, in an antique shop in Pasadena in 1986. The pencilled inscription on the back reads, "548, 3-6" There are no other identifying marks.

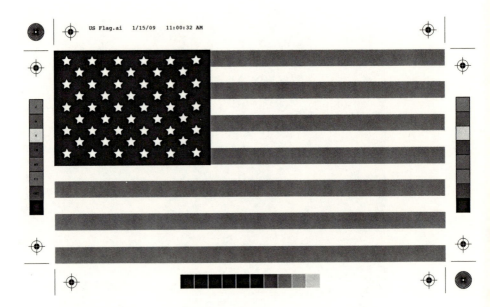

US Flag.ai 1/15/09 11:00:32 AM

I designed this book to be printed in black and white for two reasons. The first was cost. The second was to keep the document malleable by printing it on demand so it can be up-dated and added to as the field changes and contributions are made by colleagues. However, this does make a discussion of color photography difficult to illustrate! I therefore have chosen to print this copy of the flag as most likely, you the reader, will see it in color. It is also included to express my thanks to the United States for all it has given me, not only with respect to my photographic education, but also for the creativity of its people. Image by the author. True Colors. *2009.*

ASSIGNMENT

Refine your observational skills with respect to the interaction of light and color.

RATIONALE

Color is an effect produced on the eye and its associated nerves by light waves of different wavelength or frequency. Light reflected from an object to the eye stimulates the different color cones of the retina, thus making possible perceptions of various colors in the object.[3]

3. From the Columbia Encyclopedia, Sixth Edition. *Columbia University Press, 2000.*

It is important to realize that color photography is a very different medium to black and white photography. This also extends to the personality of the photographer. Most students will have a preference and/or differential abilities when it comes to fluency in either black and white or color. It is worthwhile discovering where your natural inclination lies. Irrespective, there are two fundamental issues that must be fully understood:

- There is no such thing as a colorful object in and of itself.
- The subject of color photography is color.

When using color film for the first time, students often gravitate to what they consider to be colorful subjects. Objects such as flowers or amusement parks are chosen because these kinds of objects/places/events are regarded as colorful. However, as often as not, the images of these objects are not. As often happens, there is a victory of knowledge over observation. The thought process works like this: "I have color film in my camera. I will select a subject I know to be colorful. My pictures will therefore be color pictures."

What is ignored or overlooked is that the color of an object in the first instance is modulated by, and subsequently

transmitted to, the camera by light waves. Daylight, or white light, is the sum of seven elementary colors added together. These can be viewed when daylight is broken up into its components with a prism. Because different wavelengths of light bend (refract) at different angles when passing through a medium like glass, we can see these components as separate colors. These colors (in order) are red, orange, yellow, green, blue, indigo and violet.

Thus we only perceive color by the light reflected by (or transmitted through) an object. There is no way a red ball will always look the same in any or all light. The ball has certain physical properties that permit it to absorb some portions of the spectrum (mostly blue and green) and reflect only the red portion. Similarly a translucent object looks the color of the wavelength of light that is permitted to pass through it, rather than be absorbed. Interestingly objects like a white ball (one that reflects all of the wavelengths that fall upon it) and a black ball (one that absorbs all of the wavelengths that fall upon it) are not considered to have any color at all in the sense that a white ball reflects all of the elementary colors mixed together, and a black ball represents their absence by absorption.

It should be apparent that there are a number of extremely important consequences for the making of color photographs. The first and most obvious of these is that very seldom is white light really white. For the spectrum to manifest itself in all seven of the elementary colors, then these have to all be present in the first place. The only time this occurs is when you have a light source that is made up of all the wavelengths of the visible spectrum. This most usually occurs when there is direct light from the sun, or you are using a calibrated strobe light source. Very few other light sources will possess all the seven elementary colors in sufficient quantity to make a difference.

The most dramatic example of this is to ask, "What color does an object appear to be at night?" However, this is an extreme example. More to the point is the fact that even daylight is seldom a constant quantity. The quality, and color, of morn-

ing light is very different to that at midday and both tend to be cooler (or bluer) than late afternoon/evening light. Making things more complex is the variety of artificial light sources which are beamed at us daily and nightly and the complex interactions between these light sources and the light of the natural world.

It is one thing to state this, and another to observe this, due to the phenomena known as constancy of vision. As we have just seen, the colors of the world are in a constant state of flux. But it is also a fact that even though the light shifts and changes over the day (and into the illuminated evening) objects stay the same. We know that the flag stays red, white and blue. We know that a baseball is always white. We have to know these things because if we were entirely at the mercy of our senses, then we would always be re-adjusting to the existing level and color of illumination, continuously engaging in a process of learning and re-learning as we move through the world. If it were not for constancy of vision we could easily leave our cool, blueish-pink car in the parking lot in the morning and be unable to recognize it as being the same object as the hot orange-red vehicle parked in the same spot when we came out in the late afternoon.

It is not an exaggeration to say that this phenomena is a survival imperative for most aspects of life. However, it doesn't help you survive a course in color photography! Again, as we have discussed before, cameras are sublimely literal, even dumb devices. To the camera, if the object being photographed is for example illuminated by a greenish fluorescent light, then it is going to produce a green looking picture, no matter that we know the "real" color to be something else. Just as it is necessary to train our eyes to see patterns of light rather than recognizable objects in black and white photography, so in color we have to train our eyes (or more correctly our brain) to accept the validity of discreet, time and light specific appearance, in preference to known qualities. This is simultaneously difficult and enormously engaging.

DESCRIBING THE COLOR OF LIGHT

One term employed to describe the color of light is color temperature. It helps to visualize this scale superimposed over the spectrum of visible light.

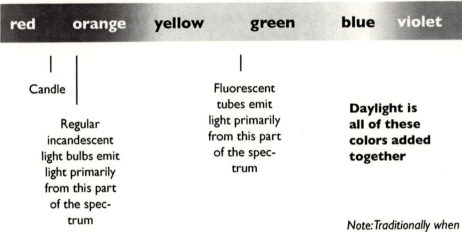

The unit of measurement is expressed in degrees Kelvin. It is useful to study this diagram as it will assist you to more carefully appraise the color of light sources when you go out to photograph. Because of constancy of vision, our eyes adapt very quickly to differing light sources. Thus when inside in a room illuminated with normal Edison screw light bulbs in place, we see things we know to be white, as white, just as we would see them as white if we took them outside during the day. However, if we use daylight balanced color film to record them, the white object when photographed under the incandescent illumination will appear distinctly yellow.

Note: Traditionally when depicting the visible light spectrum, the color indigo appears between blue and violet. For sake of clarity it is omitted in the drawing above.

The reality is that once you are aware of this phenomenon you can very clearly perceive it. You do not need color film to appreciate this phenomenon. It merely takes a bit of practice and careful observation. The best way to appreciate

this fact is to set up a desk lamp near an open window. Place an object next to the light. Notice its color appearance with the light turned off. Now turn the light on. You will see how red it looks in comparison. Do this a few times. Open and close the blinds to shut out the daylight. Also look carefully at how the color of the shadows change when you do this.

Once you have started to sensitize your mind to this phenomenon you will not be able to stop noticing just how many different light sources and variations in daylight colors there really are in everyday life. These days there are many varieties of light sources. Fluorescent tubes are particularly common and produce a sickly green glow on the subject, almost outrageously apparent once you start to sensitize your eyes. Observe how different street-lights emit different parts of the spectrum. Also, as you walk through a neighborhood at night, notice how different rooms in the houses emit different colors. Often the kitchen and bathroom are a characteristic (fluorescent) green, the living room a warm (incandescent) yellow and the TV room an almost unearthly blue interrupted by surprisingly bright, even violent, bursts of color and light.

This observation of color temperature is one of the key aspects of color photography. More than any other technique, an increased sensitivity to light and the color of this light, will influence the appearance of your images.

The second important issue is to realize that in much the same way that the subject of black and white photography is light itself, the subject of color photography is color itself. To simply put color film in your camera, and proceed as usual will not produce a color photograph. It may well produce a photograph that has in it some color, but this is not the same thing at all as a color photograph. A color photograph MUST integrate the subject matter and its illumination in such a way that the color is an integral part of the content. This is not as difficult as it sounds. In fact, when you stop and reflect on just how abstract an act it is to render the world in only tones of gray, color photography is in comparison (at least in theory) so much easier. Quite literally, what you see is what you get.

The trick is to see more in the first place!

A SERIES OF PRACTICAL EXERCISES

I have found the following exercises to be useful in refining ob-
servational skills, especially those connected with the percep-
tion of color. None of them are thematically proscriptive so
they can be applied as riders to any other assignment you may
be given by your instructor. All are simply aimed at making the
perception of color a more conscious process and in no shape
or form should interfere with your expressive or communica-
tive aims or desires or those of your teacher.

Juxtaposing Color.

Try to frame your image so there are three main colors in the
frame. Try to arrange them so each of the colors occupies
about a third of the area of the image. Do NOT simply put them
side by side like an Italian or Irish flag. The idea is to, for ex-
ample, get in the image equal portions of say, blue, yellow and
red. However, these should be dispersed through the image so
when you add up the various bits of each color, they come out
to around a third of the total area.

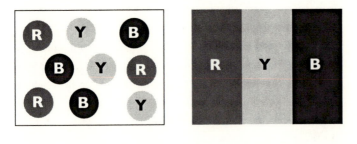

YES NO

The point is not to guide you into a specific compositional
strategy but to make you highly aware of color and how its
distribution can alter meaning. However, be aware of the trap
illustrated opposite.

You will notice that the top half of the frame is blank! This occurs surprisingly often with students who have already been studying black and white photography and have got into the habit using the sky as a kind of blank background for events occurring in the foreground. When color film is then used there remains the residual habit of ignoring the sky as if it wasn't part of the frame. It seems a statement of the obvious but the sky possesses color! Thus we can have an image where the colors are dispersed as suggested in the foreground, yet still have nearly half of the image typically blue. It is as if it were the sky was invisible.

In simple terms, don't forget that the sky too has color!

Photographing with different light Sources.

There is nothing like photographing consciously with different light sources to realize how much color is a function of the light source. Simply expose a few frames under various conditions and evaluate the results. Try candlelight, tungsten (incandescent) light, the light from fluorescent tubes. Additionally much valuable data can be obtained by making images at different times during the day. Observe how the same subject can be rendered very differently by photographing early in the morning, around noon and again late in the day or even well into the evening.

And its Corollary:

Photographing with Mixed Light Sources.

Around twilight the light of the natural world is at a similar level to the light of many artificial sources. The lights from many commercial business such as gas stations and street lights often are turned on while there is still extant daylight. If you are patient there will come a time when the natural lights source and the man-made light sources are the same value. See what happens when you photograph at this time. A particularly good example of this is Joel Meyerowitz's book *Cape Light*.

Additionally, when working in a more controlled environment like the studio, experiment with colored light and light sources of different colors. Next time you are at the theater or a concert, notice how the stage lighting employs spotlights with different colored gels over the light. Try this. Also, you can obtain great results by using colored reflectors to bounce light of different colors back into your subject. Particularly useful for this exercise are sheets of shiny, mylar, gift-wrapping paper. These sheets are inexpensive, easily obtained and give wonderful results.

Observing the Direction of the Light Source.

The other single biggest variable in controlling apparent color is to sensitize your eyes to the direction of the light source relative to the subject.

The best way to appreciate this phenomenon is to photograph an object from 4 directions, preferably in mid morning or mid afternoon when the sun is relatively (but not too) low in the sky.

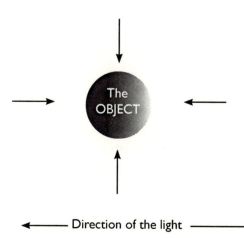

——— Direction of the light ———

In doing this you will observe that the colors appear most saturated when the sun is behind you. The optimum angle for saturation is not directly in line with the light but to have it coming over either shoulder. Notice how when you photograph across the light that the shadows (naturally) are more prominent and the saturation is less. Photographing into the light, depending on the height of the sun, can often result in an image having little or no color at all.

Make an Object you know to be One Color look as though it is a Different Color.

Try to photograph something you know to be a certain color in such a way that it appears to be something else. Obvious places to start are wet roads or other reflective surfaces. Other objects are somewhat trickier.

Mix Warm Colors with Cool Colors.

Sometimes you see a colorful subject. For example: a very red sunset. You photograph it. It is indeed very red. So red in fact that it may as well be photographed in black and white and toned red.

Instead, practice juxtaposing colors within the image so there is a mix of warm and cool colors. See what happens when you vary the relationship. For example, photograph a predominantly cool scene yet include a splash of warm. Reverse the relationship. Experiment by mixing them more equally.

Juggle Many Balls.

How many colors can you mix in the photograph while still maintaining a sense of coherence?

CONCLUSION

As simple as these things sound, they will all have a profound effect on the eventual appearance of your photographs. The only real technique in photography in general and color in particular, is the level of observation you bring to the world. No amount of filtration, either at the time of photographing, or in the darkroom (real or virtual) and no fancy bit of equipment, can substitute for a well-observed image.

In all photography, but especially in color, the quality of attention at the moment of exposure is the critical variable when it comes to how your final print will look. Unlike black and white printing, where no matter what your image looks like you can adopt the Pee Wee Herman defense of "I meant to do that," color printing tends to be either right or wrong. A color print cannot generally work if it is too light or too dark, or has a pronounced color cast. With black and white you can make a high-contrast or flat rendition of your negative. You can burn and dodge to your heart's content. However, these variations when applied to color printing on the whole, quite simply, look wrong.

IMPLEMENTATION

The reader will observe that content or subject matter is not discussed in these exercises. I have simply described how I as a teacher have employed these exercises.

Usually I ask general questions about content and subject matter, but in the exercises described above the reader will note that no such questions have been asked. I do this because it is interesting to see what subject matter and content students gravitate to when given a specific visual strategy but no guide as to content.

The concomitant responsibility therefore lies in how the discussion ensues after the images are made. Questions must be asked such as: "Why did you go here? Have you noticed how frequently you are drawn to X, Y and/or Z?"

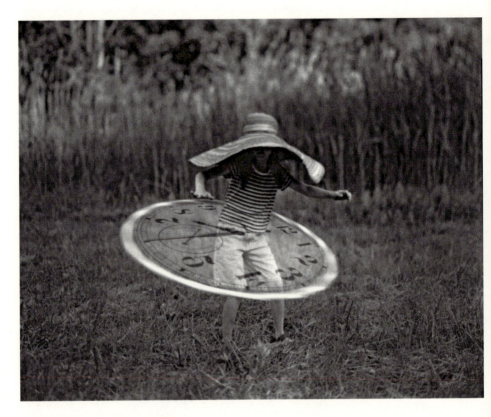

Margaret Fox. Timepiece. *2004.*

PART TWO: TIME AND SPACE

ASSIGNMENT

Make Time itself the Subject of the Photograph.

Time passes but where does it go?
Peter Stanbury

RATIONALE

When we look at almost any still photograph we are looking at a view of the world that has neither past nor future. The event is discrete, isolated, but paradoxically, un-fragmented. Each part of the image stays the same as we look at every detail in our own time, and in our own manner, secure in the fact that something important is not going to slip away as often happens in the normal flux of life. It is almost as if time has ceased to exist. This is a highly abstract, even privileged point of view, but is now so normal that the extreme deviation from natural perception it represents is simply either taken for granted, or not noticed at all.

Thus in a strange way time is always the subject of a photograph. The photographer and photo-educator Wynn Bullock believed that space literally cannot exist without time. He states, "In the real world the three space dimensions have no existence except as mathematical concepts. Only when the fourth dimension, time, is added do they become part of the real world."[4]

Therefore, consider various ways to make this ever-present, yet elusive presence, visible.

4. *This quote is from an essay sent to Nathan Lyons regarding the 1965 exhibition,* Seeing Photographically.
The title of the essay is Photographic Education. *Wynn Bullock, 1965.*

SPECIFIC ASSIGNMENTS ON TIME

ASSIGNMENT

Show and/or compare the same subject over a period of time.

Obvious examples of such a strategy are those projects that may be loosely called re-photographic projects. The usual methodology is to find old (usually historic) views of an event or scene, revisit these places in the present, and photograph the changes over time. There are many examples of this method. (See Mark Klett and Harry Littell.) Often such studies can be quite sad as almost always the changes depicted are for the worse, rather than the better. The viewpoint behind the strategy can reflect political, environmental or personal concerns depending on the subject matter chosen. In the latter case, old images of family members when compared with contemporaneous images can often be impossibly poignant.

Louie's Lunch has been a favorite snack location for Cornell students since 1918. The 1943 World War II era photo on the left shows a midshipman and his date in front of Louie Zounakas' dog wagon. In the 2001 photo on the right, Louie's Lunch, now owned by Ron Beck, displays a God Bless America banner after the September 11 destruction of the World Trade Center.

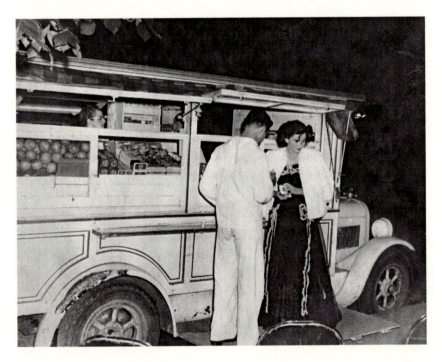

ASSIGNMENT

Juxtapose non-visual accounts of the past with contemporaneous images.

This method is a variation on the re-photographic strategy. However, in this case, the reference to the past can be more oblique. An interesting example of this kind of time travel can be seen in the work of Rochester artist, Matthew Walker. Walker combs the archives of the local newspaper, the Democrat and Chronicle, and extracts accounts of crimes and other odd events from Rochester's history. Usually such reports mention specific locations within the city. He subsequently re-visits these locations and photographs their appearance in the present.

From the book, Cornell Then & Now *by Ronald E. Ostman and Harry Littell. Ithaca, NY: Mc-Books Press, Inc., 2003.*

The combination of the old account, and the new image, combine in the viewer's mind to again evoke the passage, even tangible existence of, time.

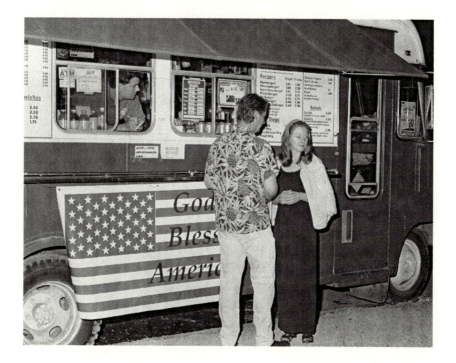

ASSIGNMENT

Create an artifact that when exposed to the elements will change over the passage of time. Either photograph the changes that occur, or simply display the objects themselves as evidence of the effects of time.

This method involves the creation of one or more artifacts that when left to their own devices will change their appearance, or even their nature. One example might be to fabricate an artifact made of relatively unstable materials such as paper or cloth and then bury it for a month or more. Time and its agents will make their mark. Other elements such as fire and water can also be employed in combination with a host of other objects and materials. The aim being to set up a system that actively employs the passage of time to function as an imaging element. (See image on opposite page.)

ASSIGNMENT

Photograph an event, either in series, or with an extremely long exposure, so that the image literally takes a long time to make.

The most obvious example of this strategy is the work of Hiroshi Sugimoto. Sugimoto describes his first attempt, "one evening while taking photographs at the American Museum of Natural History, I had a near-hallucinatory vision. My internal question-and-answer session leading up to this vision went something like this: "Suppose you shoot a whole movie in a single frame?" One afternoon I walked into a cheap cinema in the East Village with a large-format camera. As soon as the movie started, I fixed the shutter at a wide-open aperture. When the movie finished two hours later, I clicked the shutter

5. See Sugimotohiroshi. com/theater.html

closed. That evening I developed the film, and my vision exploded before my eyes."[5]

Other possibilities are endless. For example, "What does a good night's sleep look like?"

Joan Lyons soaked a dictionary in water and placed seeds on the moistened pages. In time they germinated and literally grew out of the page. This photograph was made some twenty-seven years after the seeds were planted. Over time the seeds sprouted, flourished and died. This image is literally a time capsule of this process. Even in death, their indelible marks are a poignant reminder of the passage of time itself.

Lyons entitled the work, Seed Word Book. When she subsequently showed it to a colleague it was pointed out that the words "seed" and "word" shared a common ancestry—a connection she was unaware of when she made the work. As often occurs in artistic practice, an act performed for one purpose often has meanings in excess, if not different, to those intended. For this reason the reader is reminded that the work generated in response to any of the assignments in this book may not necessarily be the answer sought, but is no less valid as a result. The point I am making is: be open to the messages your work sends to you.

Seed Word Book. *Rochester, NY: 1981. Edition of 9, from the* Natural Books *series.*

ASSIGNMENT

Use a slow shutter speed to introduce blur—not to show movement as is often suggested—but instead to suggest a moment extended.

ASSIGNMENT

Use various post-production methods such as hand-coloring, toning, drawing into the photograph etc. to engage the viewer for a longer period of time.

I have often wondered why photographs so very often are looked at, and (seemingly) digested, so quickly. This phenomenon suggests there might be a relationship between the time spent on making the image, and the time that the viewer will subsequently commit to looking at the image.

I have noticed that if one spends more time making the image—either by hand coloring it, or by employing various other post-production means—then the image will engage the viewer for a far longer period of time than if the print had been left straight. It is almost as if this investment of time infuses the image and becomes part of its content. I had a student in Australia of Greek descent who told me that the makers of religious icons were required to spend 1000 hours of prayer, meditation and work to invest the icon with power and piousness. See for yourself if this might be true.

Opposite: This icon was photographed in the Blue Mountains area near the township of Yellow Rock, about 50 miles west of Sydney. It was located in a cave on the side of a mountain in the sort of place one would reasonably expect to find Australian Aboriginal cave paintings. Instead one encounters candles, icons and other votive objects. It is said that in this cave a Greek holy man found a set of golden tablets. Nearby a temple has been erected to his memory, but the cave, with its strange mixture of Australian circumstance, and old world imagery, is a magical setting. To return to the theme, a thousand hours is almost exactly 40 days and 40 nights. From the author's portfolio, In the Cave at Yellow Rock. *1987. (Original in color.)*

ASSIGNMENT

Find a point of stillness and silence in the world of motion and noise.

RATIONALE

This assignment is based on Carter Bresson's idea of the *decisive moment*. Bresson was a master at being able to synthesize a number of fleeting, disparate elements into geometric compositions of great balance and beauty. His ideas influenced an entire generation of photographers. Much recent work seems to have forgotten, or more correctly under-emphasized, the ability of the camera to freeze isolated, ephemeral moments in favor of more static and controlled approach to the making of images. This is neither good nor bad. However, it is useful to see how the world looks, when as Bresson would say, one puts "one's head, one's eye, and one's heart on the same axis."

All within a fraction of a second.

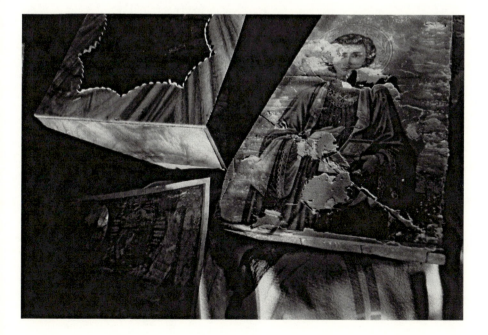

COUNTER ASSIGNMENT

The Digital Moment

Photographer Pedro Meyer proposes the idea of a "digital moment" as an antithesis to Cartier-Bresson's decisive moment. Meyer asserts that the digital medium gives photographers an opportunity to complete and revise their vision. In this elastic moment, the photograph still serves a documentary function but can continue to be revised, altered and tweaked as long as it honors the original moment. Meyer argues for the veracity of these images and claims that we must trust the creator and not the medium. Make a series of digitally altered photographs exploring this idea, while remaining faithful to the truthfulness of the situation.

Submitted by Nate Larson of Elgin Community College, Elgin, Illinois

ASSIGNMENT

Set up a system where time is the criteria for making the exposure.

Investigate what happens when you create a system for exposing images that is based on pre-determined intervals of time. These intervals can be as short as a minute or can extend to days, months or even years. Allow the moment to take control, resisting the urge to decide for yourself. The object is to break-up pre-existing notions of what you think makes a "good picture."

ASSIGNMENT

Extend a sequence in time and space.
and/or
Extend an image in time and space.

HISTORY

I became aware of this assignment and its rider whilst a student of Nathan Lyons at the Visual Studies Workshop in Rochester NY in the mid-1970's. The essential idea behind these two requests is to consider that more might actually be more. Lyons proposes that a carefully constructed sequence of images has a synergetic effect. In other words, as each image is added to a sequence, the opportunities for complexity, context and meaning grow. Lyons emphasizes the necessity to consider all of a photographer's output when reading the meaning of his or her work. The concomitant responsibility of the photographer is to produce and publish work, not as a collection of essentially de-contextualized single images, but as a coherent, self-contextualizing body of work or a series of smaller bodies of effort.

At the simplest level, Lyons asks us to clarify meaning and intention by assembling a sustained visual sequence. This can be as few as half a dozen images or as many as a hundred or more. The point is to escape from the tyranny that comes from searching for the great image or picture, and instead approach the task of authorship in a more sustained and thoughtful manner.

The second assignment is also expressed in a binary manner. Without elaboration or history consider making a series of images expressing the following pictorial/structural issues. Show what it means to:

Show the same space with a different object.
and/or
Show the same object in a different space.

ASSIGNMENT

Experiment with different vantage points.

This is another assignment from the days of the Bauhaus and the Institute of Design in Chicago. Look straight up. Look straight down.

ASSIGNMENT

Eliminate the Central Point of Interest.

Make a series of images where the subjects and/or the forms they create when photographed, are so equally spaced across the frame that the eye cannot settle on any single point.

ASSIGNMENT

Create or Eliminate Space.

Photograph a flat event such as a wall or other two-dimensional surface to make the space look deep, and by way of contrast, photograph a deep space and by carefully overlapping the forms, make it look flat.

ASSIGNMENT

When photographing, visualize the field of view as a box rather than a plane.

Rather than consider the photograph as a plane that is bounded by the edges of the frame, think instead of the photograph as a box projected out into the environment. If you can do this then you will be more open to various ways of controlling space. Try over-lapping forms in the near distance with forms that are further away from the camera. For example, connect something that is 3 feet away with something that is 20 feet away so they look as one.

RELATED ASSIGNMENTS

ASSIGNMENT

Find Words and Letters.

This assignment was originally devised by Aaron Siskind while teaching at the Art Institute of Chicago. He would ask students to find images of letters in the world and construct an alphabet. (You may choose instead to write a sentence or find/construct your name etc.) There are many levels to this assignment. In the first instance there are many examples of pre-existing letters in billboards and other public places. Secondly, there are marks and shapes in the world that resemble letters or words. Thirdly, the illusion of letters can be created by carefully overlapping forms and/or patterns of light.

Above: The letter "Y" from Joan Lyon's book,
ABECÉ (Mexico City Book 2). *Rochester, NY: 2004.*
(Original in color.)

ASSIGNMENT

Give Chance a Chance.

One of the more difficult things to do is to photograph reality directly. Frequently what happens is that a "picture," not the world itself, is seen. In other words one can look at the world, and recognize something that one has seen photographed before. Not only that, when we subsequently make the photograph, we run the risk of structuring the image in a similar manner. The net result is that we make pictures like we think pictures should look like.

To counter this Nathan Lyons would ask his students to cover the viewfinder of the camera with masking tape. In this way he attempted to shake students out of this pattern of recognition and repetition. By taping up the viewfinder an element of chance and surprise is injected into the image-making process. New visual and pictorial structures have the opportunity to present themselves. Sometimes these new structures do not even look like what we think (any) pictures should look like—the result being, that which we sought is actually found— but still not acknowledged. This is where the feedback of the instructor and the class is invaluable, for often others can see things in our work that we cannot.

EXERCISE BY WYNN BULLOCK

Describe the visual qualities of a simple object— in this case, a stone.

HISTORY

This is more an exercise than an assignment. Wynn Bullock (1902–1975)[6] would put a common, garden-variety stone in front of his students and ask them to describe the visual qualities of the stone.

6. This exercise accompanied a letter to Nathan Lyons about the exhibition, Seeing Photographically. *1965.*

FIND A STONE

DESCRIBE ITS VISUAL PROPERTIES IN WRITING

AND THEN READ ON

Bullock found that students almost invariably made comments about the hardness, softness and weight of the stone. Bullock argued that these properties are known rather than observed properties of the stone, and derived from remembered tactile experiences.

Bullock went so far as to argue that even comments about the color of the stone were incorrect responses because the color of the stone was a function of the degree to which it absorbed and reflected the ambient light and as such was not an innate physical property. This is a little harder to concede than hardness and weight, although it reminds us that, strictly speaking, any visual description of any rock should include the proviso—"in this light, the stone exhibits the following visual properties."

In brief, Bullock used this simple experiment to argue for a curriculum that included sensory training in the very different but interconnecting realms of space, color and touch:

Note: Barbara Bullock-Wilson offered the following remarks after I sent her this account of her father's exercise:

"I remember well the "Stone" exercise. He used to love doing it not only with workshop students, but also family members and friends, often using whatever was at hand—a fork or spoon that you were eating with, a table on which your book was resting, the chair you were sitting on.

Our kids still chuckle over—and continue to be somewhat mystified—by their "spoon" experiences with Dad."

Email to the author. *February 2, 2009.*

I had an important purpose in asking the students to list the visual physical properties of a stone. I wanted to alert them to an important fact. The truth that although the three; spatial, tactile and color qualities of one's experiences of the stone are all related, the psychophysical laws and principles governing these qualities are basically different. Each category represents a profound study in its own right. To confuse them is to confuse the very psychophysical laws that govern the meaning of objects at all levels. In short, to confuse what we perceive in objects, and how we perceive objects, is to retard awareness and perceptual growth.

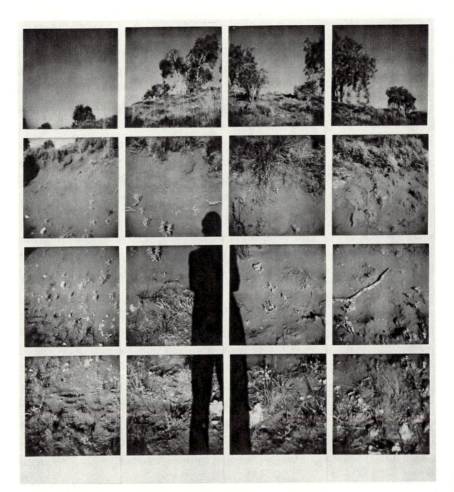

Above: Self portrait of the author in Australia.
Road Cutting with Shadow, Finke River, Northern Territory,
Australia. *From the author's book,* Visions of Australia. *Sydney:*
Angus and Robertson, 1980. (Original in color.)

CHAPTER THREE: THE "I"

ASSIGNMENTS ON DEVELOPING A SENSE OF SELF

INTRODUCTION

This chapter addresses the issues of identity and self-image. Part One, The Self, examines the most direct route which is the self portrait. It addresses the fact that the self portrait can be more than just an image where the photographer happens to be in the picture. It also examines the idea that other objects and events can function as a metaphor for the self.

Part Two, The Self and The World, addresses the notion that every image, in its own way, can be a self-portrait. However, as the opening essay of the book argues, there can be many selves coexisting in the same body. Similarly there can be many levels of attention that any one of the selves can bring to the activity of photographing.

To this end, this section also addresses some of the ways that we unconsciously filter our perceptions in such a way that we end up seeing what we want to see. These assignments will also assist the reader to seek out and utilize, in a conscious and thoughtful manner, subject matter that is relevant and helpful.

Above: This most honest and elegant image was printed from the original Kodak Box Brownie negative by Diane Dayhew, now Diane Banyard, a student, and subsequently a colleague, I was fortunate to have in Australia during the 1980's. The photograph is a self portrait made by Diane's mother on her honeymoon.

PART ONE: THE SELF

ASSIGNMENT

Make two series of self-portraits, one where you are literally in the image, one where you are not.

Once I feel myself observed by the lens, everything chang-es: I constitute myself in the process of "posing," I instan-taneously make another body for myself, I transform my-self in advance into an image....I feel that the Photograph creates my body or mortifies it, according to its caprice.... The Photograph is the advent of myself as other, a cunning dissociation of consciousness from identity."[1]

Roland Barthes as paraphrased by Martin Jay

1. Jay, Martin. Down-cast Eyes. Berkeley: University of California Press, 1994.

RATIONALE: PART ONE

2. Cirlot, J. E. A. A Dictionary of Symbols. New York: Barnes and Noble edi-tion (after Routledge), 1971.

In the early days of photography the American physician Oli-ver Wendell Holmes referred to the Daguerreotype as "a mir-ror with a memory." This elegant phrase described an image which quite literally was formed on a mirrored surface. How-ever, at a metaphorical level it could describe almost any pho-tograph made by almost any process. Nowhere is this more true than in the case than of the self-portrait.

According to Cirlot, "it has been said that (the mirror) is a symbol of the imagination—or consciousness—in its capac-ity to reflect the formal reality of the visible world."[2] It is also closely connected with the legend of Narcissus, and by association it is feminine in nature, much like the still waters of the reflective pond he contemplated. Its role in *Through the Looking Glass* is legend wherein it possesses the properties of a door to a topsy-turvy world of inversion, paradox and con-tradiction. This theme of mirror-as-portal is echoed in many

cultures when mirrors are covered up or turned to the wall on certain occasions, especially when there has been a death in the household. Additionally, and by no means exhaustively, the mirror is also symbolic of soul travel, memory, magic and the self.

It also forms the central metaphor for one of the more relevant developments of Freudian psychology in the twentieth century. The French psychologist, Jacques Lacan[3] proposed that the young child's first glimpse of his or her self in the mirror was critical with respect to the development of a coherent sense of self. Lacan argued that around the age of eighteen months when a child first sees its image in this manner, it realizes for the first time that it can be seen by others in the same way that it sees, but can never really know, other people. Consequently, it too can be an object of the gaze.

The relevance of this to the assignment is to consider his work as a graphic example of just how critical visuality, particularly self-perception and self-image, is in determining our identity. Ironically, Lacan argued that the child must rise above the tyranny of the image and base his or her sense of self on the more (at least as he tries to persuade us) protective and distanced abstract structure and/or logic of language. Nonetheless, the point is clear. Even though he downgrades the primacy of sight in the long run as a precursor to some kind of psychological wholeness, the importance he places on this stage emphasizes that the very image of oneself presents a rich, even fundamental field for photographic investigation.

Note: I am not advocating the use of mirrors per se when making your images. Instead please view the argument in a metaphorical light and consider the fact that your images can function in this manner.

3. Lacan's ideas are discussed in detail in Martin Jay's book, Downcast Eyes. op. cit. *The central thesis of the book being what Jay sees as the tendency of French intellectuals during the past century or so, to elevate the importance of language at the expense of vision.*

RATIONALE: PART TWO

The second part of the assignment expands the notion of the self-portrait to include the idea that one thing can be another. We have already discussed how photography records only appearances but have not addressed the fact that the appearance of one thing can infer the presence of another thing, or even another idea. In other words images can show one thing but mean something else. The most helpful vocabulary to describe

these relationships interestingly enough comes from the field of linguistics. Paradoxically, these language-based terms are described in a very visual manner as being "figures of speech." The main relationships are: simile, metaphor, metonymy and synecdoche. To each in turn:

To each in turn:

Simile

Note: The following discussion of these figures of speech is excerpted from the author's book, Photo-Editing and Presentation. *Rochester, NY: Clarellen, 2009.*

Similes are the simplest of these relationships, so simple in fact that they are more a convention of language rather than a true figure of speech. In a simile one object is explicitly compared with another and all the terms retain their original (literal) meaning. Thus, A is like B. For example "My love is like a rose." In visual terms a pair of images with similar forms such as a minaret juxtaposed with a space rocket is showing that the former is like the latter.

Metaphor

In comparison a metaphor states that A is B or substitutes B for A. An example of an explicit metaphor is Shakespeare's line from As You Like It: "All the world's a stage." In visual terms an image of a piece of clothing could be a representation of yourself, either now or in the past, depending on the item of clothing selected. More complex inferences can be drawn depending on how the item of clothing was arranged and illuminated. Even more interesting is the possibility that another subject altogether could be photographed in such a way that looks like a piece of clothing, that furthermore suggests a third idea or personae—such as yourself.

Metonymy

This is a situation in which an attribute of a thing or something related to it is substituted for the thing itself. Thus Hollywood

conjures up images of the film industry, lifestyles of the rich and famous etc., while the Pentagon evokes images of defense and the armed forces. Visually, a photograph of either the Hollywood sign or the Pentagon itself would function in a similar manner. One way to express this schematically might be: A is (or stands for) ab and/or ac and/or ad.

SYNECDOCHE

This concept is very similar to metonymy, the difference being that a part of a person or thing is used to designate the whole. Thus in language, a "set of wheels" can mean a car or "new threads," a new outfit of clothes. In visual terms, Alfred Stieglitz's extended portrait of Georgia O'Keeffe could be seen as an example of the use of the synecdoche. Frequently he photographed parts of her body, especially her hands, to suggest attributes of her personae as a whole. Diagrammatically one way this might be expressed is: ∧ or / is (or stands for) A.

Left: One of the more than 300 synecdochical images Alfred Stieglitz made of Georgia O'Keeffe in the early 20th Century. He photographed her hands and other details of her body to create a portrait based on parts of the whole rather than simply her image. Additionally, be aware that Stieglitz saw the entire body of work as a whole. "To demand the (single) portrait that will be a complete portrait of any person," he claimed, "is as futile as to demand that a motion picture be condensed into a single still." Alfred Stieglitz. Georgia O'Keeffe. 1933. Courtesy of George Eastman House.

THE EQUIVALENT

All of the above terms (with the possible exception of the simile) can to a degree be subsumed under the term equivalence. This notion was proposed by Stieglitz in the 1920's and 40 years later codified and promoted by Minor White. This term is very similar to metaphor and can encompass the more specific relationships of metonymy and synecdoche. However, both Stieglitz and White would say it is something more than mere metaphor.

To quote White: "When the photographer shows us what he considers to be an Equivalent, he is showing us an expression of a feeling, but this is not the feeling he had for the object that he photographed. What really happened is he recognized an object or a series of forms that, when photographed, would yield an image with specific suggestive powers that can direct the viewer into a specific and known feeling, state or place within himself."[4]

In other words White is claiming that an image can resonate in the mind of the viewer in such a way as to replicate the state of mind the photographer was experiencing when the image was made. He does not go so far as to claim that this is evidence of a universal visual language—but it is apparent that he admits the possibility of such an absolutist ideal.

Whether this is possible, likely, or even desirable is not the point. The fact remains that the search for such an ideal— no matter how simplistic it might seem in relationship to more recent theories that emphasize relativity of meaning and the complex inter-relationship between language, cognition and vision—accepts and indeed emphasizes that photographs can have as their communicable content, sets and indeed sub-sets of visual messages that can often bear only a peripheral relationship to the objects and events depicted therein.

4. See Lyons, Nathan *(ed.)*. Photographers on Photography. *Englewood Cliffs, NJ: Prentice-Hall, 1966.*

Some Ideas for Metaphorical Self Portraits.

1. Personal Identity.

Arrange, photograph, even animate, items of clothing.

Collect significant personal objects.

Childhood toys may also be a source of subject matter.

Write down and subsequently illustrate memories of childhood.

2. Family Identity.

Collect, arrange and re-photograph any letters or other family correspondence.

Do the same with any mementos and souvenirs that evoke significant memories.

Old photographs are also an obvious and excellent source of evocative imagery.

Write down memories of significant events and use these as a catalyst for your images.

3. Cultural Identity.

Religious practices and beliefs, particularly where they intersect with family memories.

Recollect and illustrate any early and deeply held or wilfully discarded religious beliefs, texts or images.

Recall significant celebrations and the way they made you feel at the time and how you recall them now.

Opposite: Sonya Naumann frequently examines her self and her identity in her work. She provided the following observations on this image.

"The Call is a scene from The Dunce Series. These are self-portraits where I am dressed in the nightgown my grandmother gave me as a child, and a dunce cap I created from canvas and a tomato fence. I print them as straight images and then re-photograph them through a dollar-store magnifying glass. They serve as an investigation into the science of memory and the conversations we have with the subconscious."

Sonya Naumann. The Call. 2008. (This image has been reformatted from a linear, horizontal schema, to fit this book. Original in color.)

SELF PORTRAIT ASSIGNMENT RIDER 1: THE MASK

Make two sets of images, one about a mask that conceals, one about a mask that reveals.

> *All transformations are invested with something at once of profound mystery and of the shameful, since anything that is so modified as to become "something else" while still remaining the thing that it was, must inevitably be productive of ambiguity and equivocation....Therefore metamorphoses must be hidden from view—and hence the need for the mask.... It helps what-one-is to become what-one-would-like-to-be, and this is what constitutes its magical power.*

> *J. E. Cirlot, op.cit.*

RATIONALE

Most of us have many identities. Another way of expressing this might be to say that we don a variety of masks. Consequently, consider the variety of masks we adopt on a daily basis. For example the mask we adopt when we go out socially as compared to the mask we adopt (or shed) in private. You might also try to imagine the kind of mask you might select if asked to reveal your inner self.

This brief introduction to the idea of the mask is presented primarily from the perspective of altering one's appearance in such a way as to project an image, be it faithful or fabricated, to be seen by others. However, the mask also facilitates the act of looking at the Other and visually scrutinizing he, she or them. Consider to what degree photography, or more correctly, the act of photographing, is in itself a kind of mask. Certainly one of the functions of a mask is to grant the wearer psychological power. This accrues when the person looking through the eyeholes of the mask is protected against a return of this gaze by virtue of the anonymity granted by the mask.

Is this not like photography itself? At the most basic level as often as not during the act of photographing, one's face is hidden from view by the camera itself. Even more importantly, the camera like the mask, confers upon the user the privilege of initiating the gaze, forcing the object of the gaze— to avoid, accept, or participate in, this scrutiny.

Therefore, should you attempt this assignment, remember that any mask has two sides. One is the side it presents to the viewer; the other is the power it confers on the wearer.

SELF PORTRAIT ASSIGNMENT RIDER 2: THE FAÇADE

The architectural equivalent of the mask is the façade. Note in the definition below how it is described as being the face of a building. Consider each of these definitions and examine their meaning visually.

1. The face of a building, especially the principal or front face showing its most prominent architectural features.
2. The way something or somebody appears on the surface, especially when that appearance is false or meant to deceive.

Another image of the entrance to Luna Park. From the authors PhD thesis, Luna Park, the Image of a Funfair. *University of Sydney, 1997. (Original in color.)*

FURTHER ASSIGNMENTS

Consider also the following assignments submitted by Nate Larson of Elgin Community College, Elgin, Illinois.

Multiple Identities.

Use the computer as a tool to make a series of composite self-portraits. The final images should appear to be photographic, but will have been subtly manipulated by combining the same person multiple times in the roles of different characters. Use the single frame to tell a story, explore an incident, illuminate a conflict, document your daily life or describe an emotional state.

Visualizing the Past:
Depict a Significant Memory.

For this project, you are to give thought to a particular memory—one that has stayed with you for a period of time. In the first instance write a series of short descriptive essays describing significant memories and their relationship to your current mental state. Based on one of these, create a series of photographs that penetrate the essence of your recollection. This work might explore the memory from a narrative standpoint, but also consider treating it in a less concrete manner.

Memento Mori.

Photography has a long tradition of serving as a memorial to objects and people that have faded with time. For this project, choose ONE significant person that has passed on and build a still life tribute, alter, memorial or shrine in the studio. You may honor a friend or family member or pay homage to a historical figure. Choose and gather objects, letters, albums, photographs, fabrics, and other items that have a relationship

with your subject and build a small set. Use your imagination and creativity to connect a wide range of objects with a variety of surfaces and textures. You may use objects that have a direct connection to your subject, but also consider objects that have a more metaphorical relationship. Create a series of photographs utilizing different types and methods of studio light to accentuate different aspects of your set.

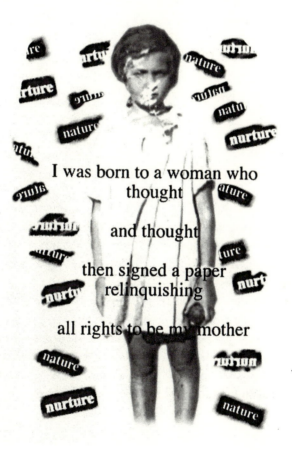

Although not strictly a studio image, this poignant collage by Carol Flax illustrates the sense of loss and homage that Nate Larson's assignment is intended to elicit.

From Flax's book, Some (M)other Stories: A Parent(hetic)al Tale. *Daytona Beach, FL: The Southeast Museum of Photography, 1995. (Original in color.)*

OTHER PERSONAL ASSIGNMENTS
MORE BRIEFLY EXPRESSED

ASSIGNMENT

Photograph the Seven Deadly Sins.

This assignment is somewhat of a chestnut but ever challenging. The Seven Deadly Sins are; lust, gluttony, greed, laziness, anger, envy and pride. A quick Google search will reveal much background information, inspiration and reasons for caution.

ASSIGNMENT

Photograph Virtue.

It is curious how there seems to be general agreement on the sins but the virtues are more difficult to define. This is probably because the virtues represent the positive aspects of one's worldview and as such the nature and number of spiritual and social values will vary from individual to individual—unlike universal temptations.

 As such think carefully about what it is you value and in what do you believe. As a starting point, as perverse a suggestion as it may be, you may wish to consider the mirror image of the seven deadly sins. However, even these are open to debate; chastity, restraint, generosity, diligence, patience, liberality and humility are just some of the antonyms.

ASSIGNMENT

Keep a Journal assiduously.

One of the most helpful strategies to facilitate personal and artistic growth is to keep a journal. It need not be fancy, nor

exhibit a high level of finish. It is enough to keep track of your thoughts, ideas, influences, and indeed your personal life. All too often excellent ideas come to mind but you are not ready to act upon them. When this happens, write them down before they escape.

Below: Journal spread by the author.

ASSIGNMENT

Instead of attempting to define identity, adopt or create a role for your self instead.

All the world's a stage and we are merely players.
 William Shakespeare, from As You Like It.

Maybe identity really is a myth. Who needs it, when we can dress and act in any way we desire?

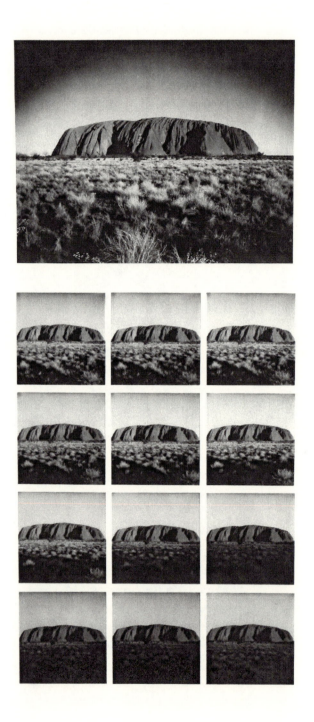

PART TWO: THE SELF AND THE WORLD

ASSIGNMENT

Find your place in the world and communicate through images, what it is about this spot that makes it yours and yours alone.

Position is where everything happens from.
Frederick Sommer.

RATIONALE

5. Castaneda, Carlos. The Teachings of Don Juan: A Yaqui Way of Knowledge. Berkley: University of California Press, 1998.

This request is based on Carlos Castenada's first experience with his prospective teacher, the Yacqui Indian shaman, Don Juan. In his first book, *The Teachings of Don Juan*[5], Castenada relates how he approached Don Juan's cabin around twilight. Don Juan listens to Castenada's request to become his student and asks that he prove his worth. He does this by informing his potential student that there is a spot (a particular place on the porch) that is his and his alone. Don Juan challenges him to find it.

Don Juan leaves Castenada alone to find this particular spot. An hour or so goes by as he tries first one part of the porch and then another. Initially he feels nothing, but as he settles down and begins to question less, and heed and feel more, he begins to understand that all parts of the porch are not the same. Some areas do feel remote, even hostile, others are warm, still others cold. After much patience and agonizing he eventually finds his spot.

Opposite: Through Sunset, Uluru, Northern Territory, Australia. *From the author's book,* Visions of Australia. *Sydney: Angus and Robertson, 1980. (Original in color.)*

To find such a spot think of a place where you simultaneously feel connected yet separate; a place that reinforces your sense of self—perhaps a place where you feel safe. You may not find your spot the first time you try. There are two things that regularly go wrong. The first thing is that you do not

make sufficient effort. You hop in the car and drive aimlessly, or walk in circles over familiar ground. The other mistake is to find the spot but visit it in an inattentive mental state. Either can occur for a number of reasons, the most common being a kind of underlying skepticism about the validity of the task.

However, it is important to realize that such spots do exist. For example, the Australian aborigines identify particular places as having a specific function with respect to the very survival of the tribe. These sacred sites can range from the location of water to more abstract and arcane notions such as being the site from which their primal ancestors emerged from the earth. To the Australian Aborigines these places are real, verifiable and a source of power and ritual.

Westerners have to a large degree lost this recognition of the sacredness of place. However, vestiges of this kind of thinking still surround us. Notice for example how particular rocks and trees attract graffiti? Consider how Muslims, Jews and Christians share jealous regard for certain sites where temples and cathedrals are successively built on top of the ruins of the other?

The discussion so far has concentrated on the place as a physical entity within the real world. However, it is worthwhile to consider other responses. A good example is the work of the peripatetic Ralph Gibson. Gibson moves from the outside world, to the intimacy of a bedroom, to the interior of a book, all the while maintaining a strange but persistently coherent sense of place and space. In his case his spot is not an external place but a highly refined sense of position. In print terms this manifests itself as a keen sense of formal composition. However, it is interesting that Gibson describes the look of his images as not being a function of compositional techniques, but instead as an act of locating himself, by as he puts it, "finding the center of his lens."

The basis of the discussion lies in the fact that photography is fundamentally an exercise in locating oneself in the world. A photograph is quite literally a point of view. It is important to realize that when you show something you are also

showing the point from which you saw something, and this point represents you.

Thus the suggestion to find your place or spot. If you can do this, very specific advantages accrue. They include:

1. Having as your subject an area or place that is of interest and relevance to you.
2. Having a firm destination in mind when going out to photograph.
3. Providing yourself with the opportunity to engage in a sustained visual investigation.
4. By re-visiting a particular place you will see it in different lights, at different times of the day and become more sensitive to variations in its appearance.
5. As your work develops you will gain an enhanced appreciation of the *differences* between your images, rather than their similarities.

One of the favorite spots of the author is Terrigal beach, a quite remarkable place located about 50 miles north of Sydney, Australia. The beach is notable for its eroded sandstone landscape. One of these formations emphasizes the notion of the "sacred site" by its strong resemblance to Jesus wearing the Crown of Thorns. Image from the author's book, Veronica. *Rochester, NY: Clarellen, 2006. (Original in color.)*

Left: Images from the Portfolio, The Last Day of Luna Park, May 30, 1981. *Opposite:* Luna Entrance, 1995. *Images by the author. (Originals in color.)*

FINDING YOUR PLACE: A CASE STUDY

Sometimes your place can find you! The images on this double page spread are from an extended documentation of an architectural site in Sydney, Australia. The place is Luna Park, an amusement park located on the waterfront of Sydney Harbor, diagonally opposite the Opera House. The investigation began when I read in the newspaper that the park was to be dismantled and its contents sold by public auction. On May 30, 1981 I made a set of images showing the appearance of the park on this day. As things turn out, this was neither the end of the park nor my involvement with it. In fact it is still there today. However, over the years it suffered many indignities as various groups argued for its preservation or its re-development. I returned many times over a fourteen year period to record its slow decay and eventual restoration.

The images on the opposite page are from the first visit in 1981. The image above was made fourteen years later in 1995 when the entrance had been restored.

When I reflect on how this place and this project changed my life I sometimes wish I had never found it—nor it me. From the author's PhD thesis, Luna Park, the Image of a Funfair. *University of Sydney, 1997.*

After studying and working in the United States for some five years back in the late 1970's, I returned to Australia. To my eyes everything looked equally good. Selecting a single vantage point was difficult as each alternative view seemed equally valid. In response I began to make images consisting of multiple exposures. Mostly these were made with a Polaroid SX-70 camera, but I also used 8x10 Polaroid film with a large format camera. The multiple image approach carried over to this larger format. The image above consists of four separate 8x10 images. You will observe that there are two vanishing points, symbolic of the desire to not place one vantage point in a position of dominance over the other. Later I realized that this also permitted the images to be viewed with a stereo viewer and appear to be three-dimensional. Image by the author, Poplar Plantation with Bovine Intrusion. *1979. (Original in color.)*

ASSIGNMENT

While photographing, participate with, rather than do something to, the world.

The overt relationship between photography, aggression and murder can be seen in Road to Perdition, *directed by Sam Mendes (2002). In this movie a contract killer "finishes off" his victims while photographing them with a 4"x5" camera. The relationship of the camera to a weapon is further highlighted, even fetishized, by Mendes' carefully crafted soundtrack. Towards the end of the movie, when the groundglass cover is opened to make the final image, the sound of this action replicates the sound of a gun being cocked before firing—a sound repeated all through the movie. See also* Peeping Tom, *Michael Powell's complex and disturbing film made in 1959.*

I am not sure whether I have actually heard the following phrase or whether it is a pastiche. Either way just think what is really being said should you hear the words:

"There is nothing I like more than going out for the day to shoot people and then spend the evening blowing them up!"

This is hyperbole to be sure. But at minimum the verb to shoot is intrinsically aggressive, if not offensive, especially with regard to human subjects.

RATIONALE

Vision is an act of participation with the world, rather than something you do to the world. This is a physiological fact. The retina collects light and transforms these impressions into minute electrical signals. Once reaching the brain they are shuttled off to various centers and are constituted into a resolved image that then is projected back to the world. Things are not seen as if on an internal screen, but appear to be "out there." This even happens while we dream with our eyes firmly shut.

In a very real sense seeing is an act of cognition as much as perception. If this were not the case then there would be few disappointing results in photography, as everything would manifest itself in the print exactly the way we *thought we saw it* when we made the photograph.

Above: Breakwater (alternate projection) Galveston, Texas. *From the author's portfolio,* Points of Entry. *1978. (Original in color.)*

Seeing is a two way street. Clarity comes as a consequence of interaction with the subject. Graphically it can be represented in the following way:

$$\longrightarrow$$
$$\longleftarrow$$

or

$$\longleftrightarrow$$

You will observe that the lines of sight travel in both directions. The eye looks out at the object and the object "looks" back. Compare this to the graphical representation of the act of shooting.

$$\circ\!\!\longrightarrow$$

In this case there is a unilateral projection from the eye out into the world. Like a gun, the camera is aimed at the subject. Instead, if you can exercise a little more patience you will one day have the unmistakable sensation that the world you have taken for granted as an unchanging objective reality is at least visually, a kind of metaphysical contract where you and it actively cooperate to conjure up an image.

Similar mechanisms are at work when we try to capture something. Like shoot, "capture," conjures up both an image of aggression and also something you do to your subject. It is an apocryphal tale in photography circles that members of some (usually New Guinea) tribe believed that a camera could steal the subject's soul. This story usually omits how the unschooled native who had never seen a camera before divined what it actually was, and could do, but it's an interesting and revealing tale. The fact that it has so much currency is probably more an admission on our part that the camera, in some unspecified way, can actually take something from the subject.

Therefore when next going out to make pictures, rather than shoot or capture, attempt instead to participate with, even listen to, the world.

Note: It is an interesting exercise to consciously remove the word "shoot" from your vocabulary when talking about photography. If you make this effort you will be surprised how often it surfaces in your own speech and that of others. What other words can you use instead?

EXERCISE BY MINOR WHITE

Learn to center yourself and see by shutting down the incessant internal chatter that passes for everyday consciousness.

HISTORY

This is more an exercise than an assignment. It is based on a procedure developed by Minor White. It reflects his search for spirit both in his work and teaching. It may well seem overly Gothic and somewhat embarrassing to perform. However, it works. It is worth enlisting the help of a friend and giving it the benefit of the doubt. If performed successfully the benefits are immediate and undeniable.

On (rare) occasions I have done something like this with my students. The occasion that most immediately comes to mind occurred while conducting a history of photography course in Ithaca, New York. I showed a Wynn Bullock photograph of a young, naked child seemingly asleep in a forest glade.

I pointed out the highly anthropomorphically charged aspects of the photograph—particularly discernible in the ferns at the top of the image and to the left of the child. My remarks were greeted with incredulity and/or blank looks. I have to say I felt the same about them. I nearly left it at that. However, on this occasion I stopped the lecture and asked the class of about 45 students to come outside with me and do the following.

Find a partner and sit cross-legged in front of each other. Close your eyes and take several deep breaths.

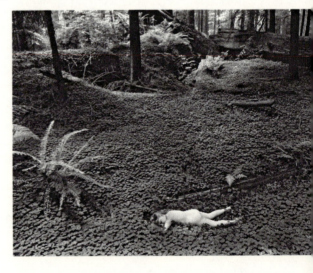

Below: Wynn Bullock. Child in Forest, 1951.

Hold the air in for about 10 seconds before exhaling slowly and consciously. Now systematically relax the muscles in your body starting with the toes. If you squeeze your toes very hard you can identify the muscle group precisely. Then do this with the arches of the feet, ankles, calves, thighs etc until you get to your chest. Now start with the fingers and work your way up your arms. Feel it all come together around your neck. Finally relax the face muscles.

By this stage your head will be pointing into the lap of the person sitting opposite. Open your eyes. What do you see? Do not look into each other's eyes.

If the exercise has been taken seriously the perception of three-dimensional space will be way in excess of what one might consider to be normal—the space between the crossed knees should look as deep as a mountain valley. This enhanced perception will subsequently transfer to other objects and events.

To return to the story: The students and I walked the twenty yards from the lawn back into the lecture theater. In silence we resumed our various places in the lecture theater and turned down the lights. I again showed the same Wynn Bullock image. The skepticism and incredulity they previously displayed, vanished.

CONCLUSION

The point is that often we seek transcendent visual experiences when we go out to make images but do not make any serious mental preparation or effort. As a result, all too often our eyes are blinded by thoughts of desire, memories, anxieties, prejudices, wishful-thoughts, concerns about what's for dinner, relationship issues, the cable bill, the offense taken at lunch, the good looking girl on the bus, or our professional ambitions.

It is worth at least attempting, if only for half an hour, to see what can be observed, and how sharp one's focus can be, if this constant noise is well and truly turned off.

ASSIGNMENT

Prove You Are Awake.

RATIONALE

In the early 20th century the Sufi mystic Gurdjieff made a number of quite penetrating observations of human behavior. He convincingly argued that most people have no center, or permanent sense of "I." Instead they proceed from one environment to another eternally reacting to outside circumstances.

To read more about Gurdjieff see P.D. Ouspenski's In Search of the Miraculous: Fragments of an Unknown Teaching. *New York: Harcourt, Brace, 1949.*

The truly astonishing thing about Gurdjieff's claim is that it was made decades before the Russian psychologist Pavlov began to prove in a more scientific manner, that identity might well be a construct dependent entirely on external circumstances when, in the mid 1920's, he demonstrated that specific stimuli could produce a predictable behavioral response. His most famous experiment was when he rang a bell before feeding a dog. After a series of learning trials the dog would salivate at the sound of the bell whether food was present or not. The psychologist B. F. Skinner further developed this line of thinking in the United States.

Skinner's extended Pavlov's thesis by demonstrating that behavior could be shaped by rewarding the subject when it began to approximate the desired behavior. This process known as operant conditioning could produce quite complex behavioral outcomes. Skinner and other learning theorists went on to argue that in many ways life was a series of increasingly complex learning trials, and that the nuances of adult personality and behavior could be explained as the cumulative consequence of hundreds and thousands of miniature learning experiences.

Parental approval and punishment, social interaction and all the other experiences of life acted on the organism so that over time, a personality was formed representing the sum total of all these interconnecting learning experiences.

Skinner argued that personality and/or identity may well be nothing more than a kind of black box or complex computer, storing learning experiences and ultimately processing these to produce, what looks like from the outside, a fully functioning, thinking, feeling, human being. This somewhat nihilistic vision strongly echoes makes the same point that Gurdjieff was making years before albeit in a more scientific manner.

Where Gurdjieff differed from either Pavlov or Skinner, is that he believed by a process he called "remembering ourselves" or in other words, making a conscious effort to be *aware* of our consciousness (in real time), we could free ourselves from this cycle of learning trials and actually begin to initiate action as free and sovereign human beings. At all times he emphasized that this was a difficult if not perilous task, as life is so much easier when we simply respond not truly act. However, as far as Gurdjieff was concerned, to not make this effort was tantamount to living one's life in a state of sleep.

Thus the request to prove you are awake. Be warned, this is a very difficult assignment. You may find it helpful to carefully re-read the exercise on the previous spread.

Image from the author's book, Past and Future Tense.
Rochester, NY: Rockcorry and Visual Studies Workshop Press, 1998.
(Original in color.)

CHAPTER FOUR: THE MIND

ASSIGNMENTS BASED ON DEVELOPING COGNITIVE AND REASONING SKILLS

INTRODUCTION

Opposite: Advertisement for a Graflex reflex camera, from The Camera. *Philadelphia: The Camera Publishing Company, January 1903. Volume 7, Number 1.*

The following issues and assignments are all concerned with the domain of the mind. All involve a process of analysis, the questioning of assumptions and the constant re-evaluation of one's own practice. If there is any one thread that connects the often-disparate issues that emerge, it is the role of and necessity for, research.

In the first instance there is a discussion of the need to be fully aware of the history of the medium. However, this seemingly simple request implies more than picking up a volume that claims to be a history. Each history is as much about the author as it is about photography. Therefore, the reader is encouraged to read widely but above all, critically.

The chapter then proceeds to outline a variety of approaches, all of which require a commitment to research and conscious effort.

Above: It is important to be aware of the signals from the past.
Cigarette cards in Scrapbook. *Anonymous c. 1916.*

To quote William Shakespeare, Sonnet 59.

> *If there be nothing new, but that which is*
> *Hath been before, how are our brains beguiled,*
> *Which, laboring for invention, bear amiss*
> *The second burden of a further child!*
> *O, that record could with a backward look,*
> *Even of five hundred courses of the sun,*
> *Show me your image in some antique book,*
> *Since mind at first in character was done.*
>
> *That I might see what the old world could say*
> *To this composèd wonder of your frame,*
> *Whether we are mended, or where better they,*
> *Or whether revolution be the same.*
> *O, sure I am, the wits of former days*
> *To subjects worse have given admiring praise.*

PART ONE: ON HISTORY AND RESEARCH

ASSIGNMENT

Make yourself aware of the history of the medium and use the results of this research in your work.

RATIONALE

1. Knowledge of the History of Photography.

There are a number of history textbooks and a plethora of critical articles and monographs on this subject. Each looks at the medium from a different perspective, often through the lens of personal bias, sociocultural issues or technical innovation. As such it is equally important to understand not only the facts, dates and personae described in each, but also the history of these histories. Each author will exhibit different values and biases. Defining and understanding these unstated perspectives is a rich and fertile source of knowledge and ideas that can enhance your practice.

In addition to personal bias, the author of the texts will also mirror the cultural theories, prejudices and attitudes of wider society prevailing in his or her time. The most obvious example in recent times is the welcome change in attitude towards female artists and particularly their inclusion or otherwise in the canon of knowledge.

Making things more complex is the failure of most histories to substantively address sub-categories of photography that often fall outside the umbrella of academic consideration. Frequently, ubiquitous uses of the medium such as the day to day work of commissioned professional photographers, un-archived surveillance images, personal erotica, scrapbooks, etc. often fail to show up in any meaningful way even though such uses are widespread. Actively and critically search for and be aware of these omissions.

Above: Advertisement from The Camera. *Philadelphia: The Camera Publishing Company, January 1903. Volume 7, Number 1.*

1. The historian Geof-frey Batchen found after much research, that despite the fact that Daguerre is/was credited as the inventor of photography (at least in France) that at the same time there were over twenty other active and sometimes successful, investigations occur-ring in the same field. See Batchen, Geoffrey. Burning With Desire. Cambridge and London: MIT Press, 1999.

Similarly be skeptical of routinely quoted orthodoxies dressed up as canonical fact. Partial truth can be as problematical as unadulterated fiction.[1]

2. Research as an On-going Process.

The discussion so far implies that research is something that comes before the images are made. However, research is also essential during and after the genesis of a project. If you find yourself attracted to certain thematic concerns in a consistent manner, investigate their history and cultural consequences. In your reading you will learn more about the subject and this will only further inform and enrich your work. It will also prompt the discovery of other related but heretofore, unknown issues that can then be incorporated in your work.

CONCLUSION

Be aware that if you do not engage consciously in a process of research the vacuum will be filled whether you either know it or like it. Influence is ubiquitous. Do nothing and you will still learn something but not necessarily what you either need or would like to know. Contemporary society throws images at us in a constant process of assault. Do not think it has no effect. Attempt to balance this with a more considered knowledge of the history of the medium and an active analysis of the forces that bear down upon us like a daily shower of contaminated water. Otherwise you will not be working in an innocent pristine garden as you might think, but instead in a laboratory where you are the rat, illusory goals the maze and the manufacturers of public image, your masters.

PROCESS: AMPLIFIED REDUCTIONISM

Take from the whole, a part.
Make this part, a new whole.

RATIONALE

I have coined the term *Amplified Reductionism* to describe a method of generating images that is based on a process of rigorous research, a period of analytical thinking and the subsequent generation of a hypothesis. As such, this assignment is not so much a single question to be considered and answered, but is instead an attitude towards the making of images that permits a wide variety of possible themes and outcomes.

*Above and Opposite:
Advertisements from*
The Camera. *Phila-
delphia: The Camera
Publishing Company,
January 1903. Decem-
ber, 1903. Volume 7,
Number 12.*

In the spirit of the assignment, let us look at each term, starting with the second. Reductionism is a process which identifies issues and assumptions critical to the making and subsequent use of images. Often these can be highly particular, or seemingly insignificant, some so basic we make the assumption of them being fundamental, even absolute, givens. The next step is to question and investigate the properties of these issues and consider how their use may be questioned, re-employed, used either as a hypothesis or

otherwise investigated visually—hence the use of the word amplify.

Such an approach might be deemed a theory-based investigation and is therefore, highly dependent on research and reading. Thus issues and methods employed in psychology, visual perception or the methods and assumptions of science or other disciplines, are grafted on to photographic practice in the search for new ways of making images. What is in common with all methods is a mind-set that is constantly questioning any and all assumptions.

At the very simplest level examine and analyze any of the photographic terms we use on a daily basis. For example, let us consider that everyday accessory, the filter.

Filters when applied to the front of the lens permit the same colored light as the filter to pass through the glass while simultaneously absorbing the complementary color—a fairly straightforward process. However, consider this act in metaphorical terms. What do we as humans permit to enter our consciousness and what do we filter out, either consciously or otherwise? Consider therefore defining and subsequently imaging this process of selective perception. Ask yourself how can this process be made visible? What does your individual filter both permit and deny, entry to your mind, or possibly even your eyes? The obvious corollary is to apply this method of thinking to other aspects of the medium. Consider the meaning and psychological resonances of other terms such as focus, develop, fix, shoot, capture and magnify—let alone, infinity

If we can do this for such simple terms, how much more complex and rich are the fields of education, book publishing, taxonomy, the scientific method, and museum practice? For example consider an investigation based on the theory and practice of the art museum. (See overleaf.)

SAMPLE ASSIGNMENT OF AMPLIFIED REDUCTIONISM

Examine the practices and procedures employed by art museums and conceive a visual investigation based on an aspect of this research.

RATIONALE

Art museums are so much a part of contemporary life that it is difficult to imagine the world without them. However, like their partner, (the medium of) photography, public art museums are for the most part a nineteenth-century invention and as such are a relatively recent phenomenon in the history of western culture and art. Until their inception artworks were tied to both their place of origin and ritualistic function. Religious works were housed in churches, portraits of royal families were displayed in palaces, and images of abundance were confined to the houses of the wealthy. However, with the advent of common, publicly accessible venues for the presentation of all these visual manifestations of value (either spiritual or material) the objêts d'art housed therein needed to be cataloged, classified and displayed. As a consequence a number of things occurred.

Note: This discussion is based on the Introduction to the author's book, Better Things. *Rochester, NY: Clarellen, 2004. See the Bibliography for the internal Malraux reference.*

Firstly, the relationship of a work of art to its site, and its original, often ritualistic use, was severed. This process of secularization emphasized the perception of an image as an artifact. Malraux describes this process as "transforming the artist's visions into pictures as it transformed the gods into statues." Even portraits changed in nature and became examples of an artist's oeuvre rather than the person depicted in the painting.

Additionally, the experience of art became more intellectualized. The art museum necessitated a classification system to contextualize what were necessarily fragments of a greater whole. Instead of the temple or church providing a built-in or more correctly a built-around framework of meaning, now labels and other supporting data became an

essential part of the display. As Malraux observed, "in the art museum each exhibit is taken to mean something different from itself, this specific difference being its raison d'être and the justification for its presence there. In the past a Gothic statue was an integral part of the cathedral…and was never expected to consort with works of different mood and outlook. Every art collection is an anthology of contrasts."

This need to categorize, collate and organize a collection is a double edged sword. It is necessary to make the collection accessible to the public but the process can sometimes limit our reading of the artworks. This can occur if we dwell too much on context rather than individual images. The risk exists that the works are evaluated and read by how well they fit in to a variety of categories and conventions. These categories include, but are not limited to, genre, medium, authorship, cultural significance and position within any art philosophy and/or movement. All of these things can subsequently combine to make us often look at the artwork on display as, in turn, a portrait, an etching, a Picasso, a Medieval religious work, an Impressionist work, etc. Thus specific images with specific messages can become instead exemplars of larger (often language-based, non visual) ideas. Rather than messages, they run the risk of being perceived and read as pigeon-holed objects.

In view of the above, look at the following list of just some of the conventions of museum practice. Note how each can be framed as a question.

Museum and Curatorial Practice
Categorical Systems used to Display the Collection
 i. How does the meaning of individual pieces of art change when they are grouped according to the era in which they were made?
 ii. What happens to meaning when genre is the only connection between individual pieces of art?
 iii. What effect is created when the place of geographical origin (irrespective of time) is the organizing principle?

iv. Is a system based on the artist's choice of medium a satisfactory coalescing device?

Record Keeping Systems

i. What is the relationship of the database to the artworks it catalogs? Is the database itself art, or a map, or a new territory?

ii. How does the use of wall labels direct and shape the viewers response to the artwork?

Display Conventions

i. How does the arrangement of images on the walls affect their meaning?

ii. Are the thematic strains of each room imposed upon the work or are they derived from it? If the latter; what is the nature of the "it"?

iii. How much of the display of the work is about the art museum's architectural form and layout rather than the artworks themselves?

Historical and Cultural Consequences

i. What happens to the meaning of a votive relic, e.g. an altar, when it is displayed in the category of sculpture?

ii. What happens to our understanding of the role of the maker of such a piece when his or her work is placed in an art context?

What is the Role of the Audience in an Art Museum?

In conclusion, apply these principles to books, education and the sciences. Ask lots of questions!

Below and Opposite: Shown are three spread views and an excerpt of the text from the author's book, Better Things. *This book examines the categorical systems that museums employ to display their work. The main thesis of the book is that these systems can "hide" the meaning of the artworks, presenting them instead as exemplars of style, media or periods of time. Thus the argument that these images should be "read" rather than simply seen as precious objects.*

Better Things. *Rochester, NY: Clarellen. 2004. (Original in color.)*

To visit a museum is literally to enter a giant, three-dimensional book. To read this "text" however, one cannot rely on the safety and order of the conventional codex. There is no identifiable sequence and no road map to steer you through the maze. Instead museums present a series of cultural or spatial cues. Hence the Medieval gallery, the Renaissance room, the Native Art display, the Twentieth Century Art section, etc. These systems serve the vital function of making the collection accessible. However, they sometimes mask the fact that Medieval, Renaissance, Indigenous and Modern artists were people—people with more in common than not—despite differences in geographic location, cultural systems and place in time. All were born, had relationships, sometimes married, had problems, experienced joys, faced death, sustained (and sometimes created) belief systems, and died.

These human experiences and values are manifested in most art in most cultures. Each culture in its own way, and in its own time, finds the means to give form to these simultaneously abstract but very real qualities and events. To share them at a personal level we need only shed the false comfort that comes with the cocoon of category.

RELATED ASSIGNMENT

Make a Wonder Cabinet.

Cabinets of curiosity or wonder cabinets became popular during the Renaissance and especially during Victorian times in England as a result of the aristocratic class traveling the world, finding strange objects in exotic locales, and bringing them home to display in special rooms. These displays were part travelogue, part scientific investigation and part innate human wonder about the world – in short, existential displays. The format of museums as we know them today were born out of the wonder cabinets of 16th–19th century Europe.

Create your own wonder cabinet by photographing individual objects in your collection from a museum that never existed or has yet to exist.

The objects you find or select should collectively reflect your interpretations about the nature of human, animal or imagined existence. The success of cabinets of curiosities or *wunderkammer,* as the Germans like to say, is often determined by the degrees of oddity and uniqueness of the objects in a collection. Think of your resulting images as an image-inventory of a small, strange museum of what you have found to be exotic, peculiar, odd, un-nameable, foreign, or unexplained. What is strange and odd in the world is generally more a matter of your *perception* of something than what the something actually is. Objects in wunderkammer were made up of, but certainly not limited to, fossils, fabrics, fetishes, insects, natural history objects, medical devices, maps, and ephemera (objects, paper, printed matter).

By way of reference, research the work of Marcel Broodthaers, Joan Fontcuberta, Mark Dion, Bernd and Hilla Becher, Margaret Stratton, John Freyer and Jacinda Russell.

Submitted by Peter Happel Christian, Assistant Professor of Photography, Youngstown State University, Youngstown, Ohio.

Opposite: Chamber
of Hope. *From the
author's book,* Love
Song. *Woodford, NSW:
Rockcorry, 1995.*

PART TWO: ON EVIDENCE

ASSIGNMENT

Consider the nature and uses of photography in the construction of evidence.

RATIONALE

Photographs are often used to perform the function of evidence.

Probably Fox Talbot, the inventor of the Calotype process, made the earliest observation that photographs may be used in this manner. In the *Pencil of Nature,* the first photographically illustrated book ever published, there is a caption accompanying a photograph entitled *Articles of China.* In the caption Talbot claims that "should a thief afterwards purloin the treasures—if the mute testimony of the picture were to be produced against him in court—it would certainly be evidence of a novel kind."[2]

On the other hand, photographic evidence is literally manufactured (fabricated?). Unlike (to use a criminal example) combing the scene for clues, interviewing witnesses or establishing alibis, photographic evidence requires that a paper object be created that conforms to certain rules of visual depiction so that the image will be perceived as truthful and a legitimate depiction of an event. In so doing the photo-critic John Tagg argues, a photograph is "produced according to certain institutionalized formal rules and technical procedures which define legitimate manipulations and permissible distortions in such a way that, in certain contexts, more or less skilled and suitably trained and validated interpreters may draw inferences from them, on the basis of historically established conventions." Tagg goes on to argue that such a process cannot produce a phenomenological guarantee of prior existence.[3]

2. Fox Talbot, William Henry. The Pencil of Nature. *New York: Da Capo, 1968 (facsimile edition) Plate 3. Originally published in 1844.*

3. Tagg, John. The Burden of Representation. *London: Macmillan Education, 1988.*

Thus we have an intrinsically contradictory situation. On one hand there is no doubt that photographs have great veracity, by trading on "the prestige of the real,"[4] on the other hand this evidence is man-made (sic) and subject to bias, serendipity of viewpoint and at times outright distortion, if not deceit.

4. Sontag, Susan. On Photography. New York: Farrar, Strauss and Giroux, 1978.

Accordingly consider some of the following assignments as just a few of the ways that this paradox, or if not paradox, disconnect, can be investigated visually.

ASSIGNMENT

Take images made as evidence for one world-view, function as evidence for a different perspective.

RATIONALE

5. Sultan, Larry and Mike Mandel. Evidence. Santa Cruz, CA: Clatworthy Colorvues, Greeenbrae, 1977.

In their book Evidence, Larry Sultan and Mike Mandel[5] deliberately set out to question, if not undermine, the evidential nature of photography. Their method was to scour the records of hundreds of government and corporate image files and select images of often quite strange and mysterious events. In all cases the images were originally made for the most prosaic and applied reasons. Photographs of highway embankments, scientific experiments and various images of workers involved in the act of measuring or otherwise defining space in the "real world" are surreally juxtaposed to construct a purely visual narrative. There are no captions, no dates, no mention of place. Instead the viewer is presented with an extended sequence of disembodied visual artefacts that require interpretation on the basis of visual form alone.

Therefore, consider recontextualizing found images in such a way as to create new and unintended meanings.

ASSIGNMENT

Accept the malleability of meaning inherent in the photograph (especially the historical photograph) and use it to create your vision of the past.

RATIONALE AND PRECEDENT

Perhaps the most dramatic example of this is the work of Michael Lesy. In *Wisconsin Death Trip,*[6] Lesy uses photographs and excerpts from newspapers of fin de siecle America to construct a collage of visual and written artifacts to create a picture of a society obsessed with death, suicide and disaster.

6. Lesy, Michael. Wisconsin Death Trip. Pantheon Books, New York. 1973.

The resulting document purports to be a picture or image of this time in American history, a time when Lesy argued, America began to go crazy, but the selectivity of the data and the re-contextualisation of commercial and editorial photography casts serious doubts on its true nature of an image of a time and place. Lesy's approach is condemned by Sontag who argued:

"Of course, *Wisconsin Death Trip* doesn't actually prove anything. The force of its historical argument is the force of collage. To Van Schaick's disturbing, handsomely time-eroded photographs Lesy could have matched other texts from the period—love letters, diaries—to give another, perhaps less desperate impression. His book is rousing, fashionably pessimistic, polemic, and totally whimsical as history."[7]

Such arguments indicate the treacherous nature of photographic evidence. Be also aware that fabrication has its inherent problems, especially if we are to believe Umberto Eco. In his novel, *Foucault's Pendulum,* Eco describes a situation where three co-conspirators decide to create the history of a secret society. Their creation based partially on fact, partially on randomly created text and partially on sheer imagination assumes its own authority and terrible consequences ensue. One of the three dies of cancer, the second is hanged, and the third withdraws to reflect in isolation and misery.

7. Sontag, Susan. On Photography. op. cit.

This caution is included not to inhibit, but to warn.

ASSIGNMENT

Create a Digital Conspiracy.

Below: Patrick Nagatani creates elaborate tableaux that show modern artifacts, in this case a BMW automobile, in unlikely archeological circumstances.
BMW, Chetro Ketl Kiva, Chaco Canyon, New Mexico, U.S.A. 1997/1998

Apply your digital manipulation skills to deliciously deceitful ends—in other words, tell a deliberate lie. Use your photographs to document a moment that never was, and convince the viewer of the veracity of the event.

See the work of:

Creation of Fictional Physical Landscapes: Patrick Nagatani and Sergio Vega.

Creation of Cultural Structures: Paul Zelavanski.

Submitted by Nate Larson, Elgin Community College, Elgin, Illinois

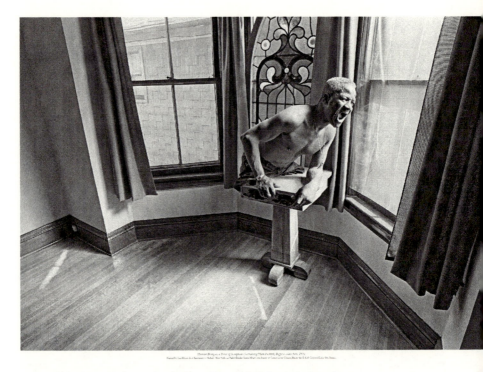

One of the photographers who deeply influenced Coleman's thoughts on
the directorial mode was Les Krims. Krims describes his images as fictions,
yet they depict, or more correctly, create, a terrible and fantastic reality.
In saying this I am using these words deliberately and literally.
Les Krims. Human Being as a Piece of Sculpture (Screaming Man
Fiction). *Buffalo, New York, 1970.*

ASSIGNMENT

Create a real fictional event and then make an (un)real document.

RATIONALE

The term *directorial mode* was coined by the critic A. D. Coleman[8] to describe a way of making still photographs in the manner of a director crafting a film. In film the director exercises total control over the subject matter, the lighting, the camera's point of view and the nature, appearance and characterization of the actors. Seldom does chance or un-judgmental observation enter the picture.

The main aspect of the directorial mode is the creation of events, objects and tableaux, in other words, fictionalized events, that subsequently, when photographed, trade upon what is left of photography's veracity and believability. At the time Coleman made his comments, the photography world was dominated by a purist aesthetic that these days seems quaint, if not downright naive. Currently, the directorial mode has gained wide acceptance, to the point that it seems naive to even point it out. However, it must be remembered that directorial photography is not simply a "given" but is in fact a school of thought, and like any school of thought, should be seen for the collective set of assumptions and practices that it really is.

Because such an approach represents an attitude rather than any strict method it embraces a wide variety of visual and thematic concerns. There are many variations evident in contemporary photographic practice some of which are presented in assignment form overleaf.

8. *Coleman, A. D.*
Light Readings. A
Photography Critic's
Writings 1968-1978.
*Albuquerque: University
of New Mexico Press,
1998). Second edition,
revised and expanded.*

ASSIGNMENT

Create a performance with the intention that the finished product be an image, as much if not more, than the performance itself.

RATIONALE

During the 1970's and 80's, performance art emerged as a viable and vital aspect of artistic practice. The difficulty is of course, that such events by their very nature are ephemeral and site specific. As such, accounts of this work—primarily photographs— were often the only evidence that they ever occurred. These photographs were for the most part documentary in nature in the sense that they were records of actual events and intended to show what these events looked like. However, the photographs themselves were the artifact that entered the documented history of this form of art. As such consider making images of performance events with the idea that the images are the finished product and have a life and structure of their own.

Do not simply document these events but consider how, by using alternative viewpoints, lighting techniques and other devices, a "third effect" can be created where the image of the event is so specific to the act of photography that it presents an impression that in all likelihood would not even be seen by a normal viewer watching the original event.

Above: Image of the author, made in collaboration with Paul, in a very old and beautiful Volvo, just minutes before we went together to see the first showing of the movie, One Flew Over the Cuckoo's Nest, *in Berkeley, CA. Paul Diamond.* Hopi Bridgework. *1975.*

ASSIGNMENT

Create a Narrative Tableaux.

Construct scenarios in the lighting studio where one or more actors reconstruct scenes from everyday life, history, mythology, biography, or fantasy. The studio becomes your stage, and like a good director, you should carefully consider all of the elements on your stage and their symbolic and metaphorical meanings. Everything should be there for a specific reason—to advance the narrative. The scenario ideally will include both human and non-human elements.

Submitted by Nate Larson, Elgin Community College, Elgin, Illinois

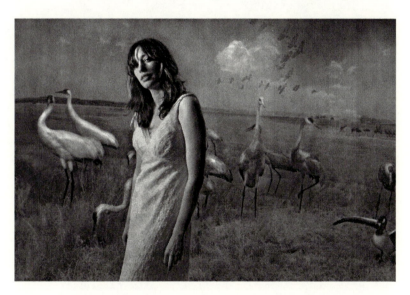

Above: In the Thousand Dollar Dress *project, Naumann is photographing 1,000 women (and to quote Sonya,"a few courageous fellas") wearing her $1,000 wedding dress within the context of their own or a mutually chosen environment.*

She writes: "I am facilitating an open dialogue concerning the institution of marriage and seek to explore the diverse views attached to its conception amidst the current culture war regarding its exclusive definition."

Sonya Naumann. Pieta. *2007. (Original in color.)*

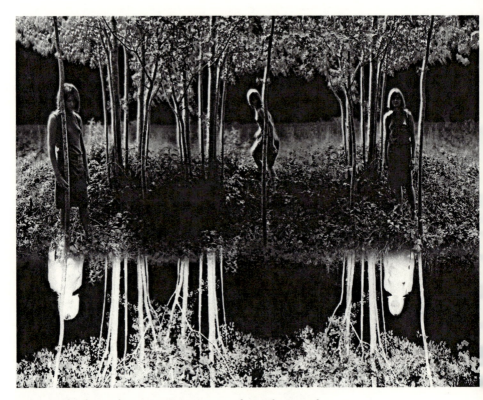

*An example of recombinant imagery using traditional materials.
Uelsmann's darkroom contains around a dozen enlargers. In each
of these enlargers he places a different negative. He then transports
a piece of photo-paper from one enlarger to the next, cumulatively
building up a composite image by skillful and painstaking masking,
dodging and burning. The end result is a glowing silver print.*
 Jerry Uelsmann. Small Woods Where I Met Myself. *1967.
Silver gelatin print.*

ASSIGNMENT

Construct a new reality by combining material from a number of separate images into a new single image.

RATIONALE

For most of the history of photography photo-collage was a marginal activity. A few artists notably Oscar G. Rejlander and Henry Peach Robertson in the mid-eighteenth and later John Heartfield in the mid-twentieth century, practiced this (then) difficult art with consummate skill. Probably the most recent practitioner to use this technique by using technically demanding (if not outright cantankerous) analog materials is Jerry Uelsmann who started practicing this method in the mid 1960's and is still working skillfully in the same manner to this day. It would appear that the main reason this activity was so marginal is that it was extraordinarily difficult to do, and especially to do well. However, now Photoshop permits virtually anyone to seamlessly integrate images from a variety of sources. As a result, this methodology is now employed far more frequently than at any time in the history of the medium.

Therefore, because of the diminishing barrier to entry based on technical sophistication, the challenge now is how to use this technique in an increasingly effective and sensitive manner.

ASSIGNMENT

Create body types, both idealized and abnormal.

RATIONALE

As mentioned in Chapter 3, when issues of self-image and identity were discussed, the image of the body is a rich and fertile source of image-making practice and ideas. As such, consider some of the following ideas:

1. Use the computer to construct body forms that either reinforce, question, or satirize, notions of "the beautiful."
2. Engage in a process of "photo-genetics." Employ the processes of metamorphosis and mutation to create new forms of life.

Above: Anna Druzcz. Anamorphic Operation I. *2006. C-Print. (Original in color.)*

ASSIGNMENT

Create a new landscape.

RATIONALE

Humans have always manipulated and re-shaped the natural world. In Australia, the Aborigines used fire when hunting to heard game into a place where it could be killed. The consequence of this was that fire became over time, an essential part of the eco-system. These days many plants cannot reproduce unless they are burned. On a grander scale think of the alterations that have occurred by the damming of the Nile River at Aswan, Egypt and the creation of the Suez and Panama canals.

These alterations can be simulated on a smaller scale by combining photographic elements digitally to create new and mysterious landscapes—arguably, with less damage and fewer environmental consequences!

Below right: Druzcz photographed and then re-combined, commonly found subject matter in upstate New York. She writes:

"The subject matter of the work is about the reconstruction of 'natural' environments from man-made, artificial elements. In Vista I *I photographed the tree, the hill, the concrete in the foreground, and the backdrop in different locations. By combining and juxtaposing these scattered elements collectively, which separately might be overlooked, I am able to present a more thorough view of what I think our contemporary 'nature' looks like, and make a complete and much more powerful statement with a single image."*
Anna Druzcz.
Vista I. 2006. C-Print. (Original in color.)

*This image combines scanned objects and text with
further text introduced in Photoshop.*
Secret Knowledge. *Direct scanned image by the
author, 1995. (Original in color.)*

PART THREE: ON WORDS AND IMAGES
ASSIGNMENT

Devise a means to combine Words and Images in such a way that each equally participates in the generation of meaning.

RATIONALE

One of the more interesting aspects of language is that there is a word for almost everything. No matter how obscure the fetish, phobia, or phenomenon, almost invariably there will be a single word that describes it with precision. For example, how often have you the reader struggled with my periphrasis?[9] Yet despite this, there is no word in the English language (or any other that I know of) that describes the equal, mutual and complementary juxtaposition of image and text. Instead the words used to describe image/text relationships imply that one is more important than the other. The two most common terms are "the caption" and "the illustration."

9. The use of overly long or indirect speech in order to say something!

The word caption suggests that the image is the prime carrier of the communicated content. But it also implies that the image needs clarification and that some explanatory text is necessary for it to be correctly interpreted. Similarly the word illustration also possesses hierarchical resonances, but in this case it suggests that the image fills-in the gaps, or makes more clear, a pre-existing idea that already has been expressed in words. It implies, at worst, a kind of redundancy and at best, a process of decorative embellishment.

The lack of a term that describes mutual importance suggests that such a relationship may well be impossible. However, the thought that image and text might be combined on the print or the page where each has equal weight and significance—and more to the point be perceived as a whole in an instant—is the Holy Grail of graphic communication. Such noble searches, as quixotic as they may be, are intrinsically rewarding and worth undertaking for the sheer drama and beauty of the journey.

ASSIGNMENT

Find or create a text and make images to amplify its meaning.

RATIONALE

This is a way of working that is quite common in the world of artist's books and Fine Press publications. These areas have traditionally employed text and image relationships as an integral part of the communicated content of the work.

Some of the greatest exponents of this art, such as William Blake (1757-1827) are fluent writers as well as accomplished artists. Blake frequently wrote the text and created the illustrations that accompanied it. Equally common are visual artists who are inspired by a text, and respond to it by creating their own illustrations to make beautiful and often profound statements.

The problem with working in this manner is that unless the text is older than 1924, most likely it is under copyright and cannot be used without incurring the wrath of the author or publisher. Therefore, use texts in the public domain or seize this chance to be brave, and just simply write a story. Even a short poem or prose piece can provoke interesting images.

Opposite: This photo-collage, It's always tea-time, *is from a series created by Maggie Taylor to accompany Lewis Carroll's* Alice's Adventures in Wonderland. *Palo Alto, CA: Modernbook, 2008. (Original in color.)*

ASSIGNMENT RIDERS

1. Photograph a word or section of text so that its meaning is altered by its new appearance.

2. Combine images in such a way as to use them as pictographic devices to tell a story. Create a visual alphabet. For precedents think of Native American smoke signals and the use of semaphore signals by ships at sea.

3. Find fragments of text in the real world whose meaning has been altered by neglect and/or the weather, or frame the photograph to create new contexts and meanings.

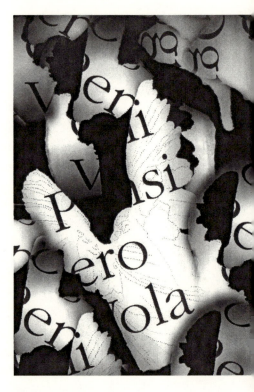

4. Look up the meaning of the word palimpsest and employ the idea of over-writing to create new, and/or multiple, levels of meaning.

5. In Photoshop, or in any program that permits, inter-weave words and images to create new, and/or multiple, levels of meaning.

6. Play with new relationships by writing down words (using various type styles and sizes) on pieces of paper and place them randomly on or near images. Observe how the meaning of both the word and the image changes.

Above: Ogni Pensiero Vola (All Thoughts Fly). *From the author's book,* Paper, Scissors and Stone. *Woodford, NSW: Rockcorry, 1994.*

CONCLUSION

Always remember you are using a medium that has an implied contract of trust and believability between the maker of the image and the viewer. It is legitimate to bend this assumption of veracity and permit the viewer to suspend disbelief. However, you are only putting yourself in danger if you exploit this trust for cynical ends.

In 2007 the television series *American Idol* produced a charity special entitled, *Idol Gives Back*. (In itself a strange, even ominous title when you think about it.) One of the highpoints of this show was a very much alive Celine Dion singing a duet with a seemingly equally alive Elvis Presley. Obviously some quite remarkable digital image stitching/grafting was going on. This fabricated, digitally enhanced Elvis was totally believable.

This was done for entertainment and the trickery fooled no one. However, one could not help but wonder how easy it might be to create a politician, either home-grown or foreign, to speak inflammatory words and thus create a real-world crisis, with real and tangible consequences. Such are the gray morals of the digital world. These may seem distant, even far-fetched issues from a student's perspective. However, all too soon you may well be wielding that mouse and exercising your skills while holding a position of influence and power—and artists have a lot of power. Never forget how we remember the competing visions of the Divine, as depicted by Giotto and Michelangelo, far more than we recall the orthodoxies, personal idiosyncrasies, and even names, of the once mighty Popes and merchants who commissioned their skills.

PHOTO–EDITING
and PRESENTATION

A Guide to Image Editing and Presentation
for Photographers and Visual Artists

DOUGLAS HOLLELEY

*Above: This book addresses the more integrative tasks
one must engage in after work has been generated.
Holleley, Douglas. Photo-Editing and Presentation.
Rochester, NY: Clarellen, 2009. (Original in color.)*

AFTERWORD
INTEGRATIVE STRATEGIES

INTRODUCTION

The reader is reminded that the assignments in this book are an aid, not an end. It is not the intention of the book to elicit specific responses to specific questions. The assignments are quite simply a device to assist you to generate work in a thoughtful manner. Having done this, the next task is to draw threads together, find commonalities and differences, and subsequently integrate one's images into a coherent and satisfying whole. Such an act (or series of acts) can be gathered together under the umbrella of *Photo-Editing and Presentation*. I have addressed many of these issues in another volume of the same name. (See opposite page.)

The Table of Contents of this volume, reproduced overleaf) summarize the range of choices available. If the reader should see this as a blatant act of self-publicity I can only plead guilty—and encourage you to purchase a copy!

The following abbreviated Table of Contents from *Photo-Editing and Presentation* lists many of the issues to be addressed when constructing a larger and more complex statement.

BASIC EDITING STRATEGIES

The Initial Edit
Method
Final Thoughts
Intention Versus Effect
Intentionality
Editing Strategies
The Third Effect
Systems of Internal Logic
 Category or Genre
 Similar Classes of Objects
 Similar Classes of Objects Occupying the Same
 Visual Space When Photographed
 Use of Recurring Visual Motifs
 Objects
 Shapes and motifs
 Color
 Metaphors and Symbols
 Simile
 Metaphor
 Metonymy
 Synecdoche
 Allegory
 The Equivalent

MACRO EDITING SYSTEMS

Grouping
On Authorship
The Narrative
The Sustained Metaphor or Sequence
The Array
Assemblage
The Moving Image
Diagrammatic Systems

PRESENTATION

General Considerations—Scale
Seven Main Ways to Present Images
The Book
The Portfolio
The Book/Portfolio Hybrid
The Exhibition
The Installation
Time and/or Screen Based Systems for Still Images
Electronic Delivery Systems
Contextualizing Your Data
Writing an Artist Statement
Conclusion

PRESENTATION TECHNIQUES

Making a Simple Concertina Book
On Demand Publishing Options
Working with Cloth and Board
Bookbinding Tools and Materials
A Two-Piece Hard Cover for a Concertina Book
Making a Two-Piece Portfolio Box
Matting Prints
Print as Object

FINAL ASSIGNMENT

Present your images so they exhibit the Quality of Thoughtful Authorship.

RATIONALE

Consider how one's thinking changes when instead of aiming to be an artist, and make art, one considers oneself to be an author and make a statement. Although the word authorship tends to be associated with literary rather than visual modes of expression, it is a very useful concept.

If for a moment we can imagine being in a creative writing course then there would be little or no need for any debate. It would make no sense at all to create a story at the end of the semester that was a hodge-podge of paragraphs collected over the semester and then cobbled together at the end to make a longer piece of work. Such a work would most likely make no sense. Yet in photography classes often something like this often occurs when a so-called good one from this roll of film, is stuck next to a good one from another.

Occasionally this can work. More frequently, it does not.

Opposite: The author's book, Veronica, *is an extended series or sequence of photographs made of the eroded rock platform at Terrigal beach in Australia. The images are nominally about the shape, structure and patterns embedded in the sandstone. However, the real story is one of creation. The images and text describe how the world was formed, and how humans were subsequently born into this world.*

In light of the assignment, the rocks were perceived and subsequently photographed as if they were a giant text—and like any text, the signs and signals locked in the rocks, demanded to be read. This is probably the greatest of photography's gifts. It is a tool that enables us to read, and hopefully eventually understand, all that the world is trying to tell us. Veronica. *Rochester, NY: Clarellen, 2006*

Image by the author from the book, Paper Birch. *2004.*
(Original in color.)

BIBLIOGRAPHY AND FURTHER READING

CHAPTER ONE: EXPLORING THE MEDIUM

ASSIGNMENTS BASED ON TECHNICAL OR
PROCESS ISSUES

Anderson, Paul. *Pictorial Photography, Its Principles and Practice*. Philadelphia and London: J. B. Lippincott and Co., 1923.
Bunnell, Peter C. *Non Silver Printing Processes: Four Selections 1886–1927*. Facsimile Edition. New York: Arno Press, 1973.
Burkholder, Dan. *Making Digital Negatives for Contact Printing*. San Antonio, TX: Bladed Iris Press, 1995.
Crawford, William. *The Keepers of Light: A History and Working Guide to Early Photographic Processes*. Dobbs Ferry, NY: Morgan and Morgan, 1979.
Holleley, Douglas. *Digital Book Design and Publishing*. Rochester, NY: Clarellen, 2001. (See Chapter 8.)
Renner, Eric. *Pinhole Photography: From Historic Technique to Digital Application*. Burlington, MA: Focal Press, 2008.

CHAPTER TWO: THE EYE

ASSIGNMENTS BASED ON PERCEPTUAL
AND/OR OBSERVATIONAL ISSUES

PART I: LIGHT AND COLOR

Coe, Brian. *Colour Photography, The First Hundred Years 1840–1940*. London: Ash and Grant, 1978.
Davis, Phil. *Photography*. Dubuque, Iowa: Wm. C. Brown Publishers, 1990.
Roberts, Pam. *A Century of Colour Photography: From the Autochrome to the Digital Age*. London: Andre Deutsch, 2007.
Szarkowski, John. *The Photographer's Eye*. New York: Museum of Modern Art, 1966, 1980, 2007.
—. *Looking at Photographs*. New York: Museum of Modern Art, 1973.
Tufte, Edward R. *Visual Explanations: Images and Quantities, Evidence and Narrative*. Cheshire, CT: Graphics Press, 1997.

TIME AND SPACE

Ostman, Ronald E. and Harry Littel. *Cornell Then & Now.*
Ithaca, NY: McBooks Press, Inc., 2003.
Sultan, Larry and Mandel, Mike. *Evidence.* Santa Cruz, California: Clatworthy Colorvues, Greeenbrae, 1977.
Klett, Mark, with Ellen Manchester and JoAnn Verburg.
Second View: The Rephotographic Survey Project. Albuquerque: University of New Mexico Press, 1984.
Lesy, Michael. *Wisconsin Death Trip.* New York: Pantheon Books, 1973.

CHAPTER THREE: THE "I"

ASSIGNMENTS ON DEVELOPING A SENSE OF SELF

PART ONE: THE SELF

Bright, Deborah. (ed.) *The Passionate Camera: Photography and Bodies of Desire.* London and New York: Macmillan, 1998.
Cirlot, J. E. *A Dictionary of Symbols.* The Philosophical Library, New York, 1962.
Freud, Sigmund. *New Introductory Lectures on Psycho-analysis.* New York: Carlton House, 1933.
Jay, Martin. *Downcast Eyes; The Denigration of Vision in Twentieth Century French Thought.* Berkeley, Los Angeles and London: University of California Press, 1993.
Jung, Carl. *Man and His Symbols.* New York: Doubleday, 1964.
Pultz, John. *The Body and the Lens, Photography 1839 to the Present.* New York: Harry N. Abrams, 1995.
White, Minor. *Mirrors, Messages, Manifestations.* New York: Aperture, 1969.

PART TWO: THE SELF AND THE WORLD

Berger, John. *Ways of Seeing.* London: Pelican, 1972.
Lyons, Nathan. *Photographers on Photography.* Englewood Cliffs, NJ: Prentice-Hall, 1966.

CHAPTER FOUR: THE MIND

ASSIGNMENTS BASED ON DEVELOPING COGNITIVE AND REASONING SKILLS

GENERAL HISTORIES

Braive, Michel F. Translated from the French by David Britt. *The Era of the Photograph; a Social History*. London: Thames & Hudson, 1966.
Davis, Keith. *An American Century of Photography: From Dry-Plate to Digital*. Second Edition. New York: Harry N. Abrams, 1999.
Freund, Gisèle. *Photography and Society*. Boston, MA: David R. Godine, 1980.
Frizot, Michel. (ed.) *A New History of Photography*. Cologne: Könemann, 1998.
Gernsheim, Helmut, with Alison Gernsheim. *The History of Photography from the Camera Obscura to the Beginning of the Modern Era*. Second Edition. New York: McGraw-Hill, 1969.
Hirsch, Robert. *Seizing the Light: a History of Photography*. Boston: McGraw-Hill, 1999.
LeMagny, Jean Claude and André Rouillé. (eds.) *A History of Photography*. Translated by Janet Lloyd. New York: Cambridge University Press, 1987.
Newhall, Beaumont. *The History of Photography: From 1839 to the Present Day*. Fifth Edition. New York: The Museum of Modern Art, 1982.
Rosenblum, Naomi. *A World History of Photography*. Fourth Edition. New York: Abbeville Press, 2007.
–. *A History of Women Photographers*. Second Edition. New York: Abbeville Press, 2000.
Scharf, Aaron. *Art and Photography*. Harmondsworth, Middlesex: Penguin, 1974.
Warner Marien, Mary. *Photography, a Cultural History*. New York: Harry N. Abrams, Inc., 2002.

CRITICISM AND THEORY

Barthes, Roland. *Camera Lucida, Reflections on Photography*. Translation: Richard Howard. New York: Hill and Wang, 1981.
Batchen, Geoffrey. *Burning With Desire: The Conception of Photography*. Cambridge and London: The MIT Press, 1999.

Baudrillard, Jean. *Simulacra and Simulation*. Ann Arbor: University of Michigan Press, 1997.

Benjamin, Walter. *The Work of Art in the Age of Mechanical Reproduction* in *Illuminations*. London: Fontana Press, 1992.

Bolton, Richard. (ed.) *The Contest of Meaning*. Cambridge MA: The MIT Press, 1993.

Burgin, Victor. (ed.) *Thinking Photography*. London: Macmillan Press Ltd., 1983.

Brown, Julie K. *Contesting Images, Photography and the World's Columbian Exposition*. Tucson and London: The University of Arizona Press, 1994.

Coke, Van Deren. *The Painter and the Photographer, from Delacroix to Warhol*. Albuquerque: University of New Mexico Press, 1964.

Coleman, A. D. *The Directorial Mode* in *Light Readings*. Oxford, New York, Toronto, Melbourne: Oxford University Press, 1979.

Gibson, Ross. *South of the West, Post Colonialism and the Narrative Construction of Australia*. Bloomington and Indianapolis: Indiana University Press, 1992.

Ivins, William Jnr. *Prints and Visual Communication*. Cambridge and London: The MIT Press, 1978.

Latour, Bruno. *Drawing Things Together* in *Representation and Scientific Practice*. Edited by Michael Lynch and Steve Woolgar. Cambridge, MA: The MIT Press, 1990.

Malraux, André. *The Psychology of Art, Volume I. Museum Without Walls*. New York: Pantheon Books, 1949.

Solomon-Godeau, Abigail. *Photography at the Dock; Essays on Photographic History, Institutions, and Practices*. Minneapolis: University of Minnesota Press, 1991.

Sontag, Susan. *On Photography*. New York: Farrar, Strauss and Giroux, 1978.

Squiers, Carol. (ed.) *The Critical Image: Essays on Contemporary Photography*. Seattle: Bay Press, 1990.

Tagg, John. *The Burden of Representation*. London: Macmillan Education, 1988.

Wells, Liz. (ed.) *Photography: A Critical Introduction*. Third Edition. London and New York: Routledge, 2004.

AFTERWORD:
INTEGRATIVE STRATEGIES

EXHIBITION DESIGN

Nairne, Sandy. *Thinking about Exhibitions.* London: Routledge, 1996.
Newhouse, Victoria. *Art and the Power of Placement.* New York: Monacelli Press, 2005.
O'Doherty, Brian and Thomas McEvilley. *Inside the White Cube: The Ideology of the Gallery Space.* Berkeley and Los Angeles: University of California Press, 1976.

BOOKS

Carson, David. *The End of Print, The Graphic Design of David Carson.* Text by Lewis Blackwell. London: Laurence King Publishing, 1995.
Drucker, Johanna and Emily McVarish. *Graphic Design History: A Critical Guide.* Upper Saddle River, NJ: Prentice Hall, 2008.
Holleley, Douglas. *Digital Book Design and Publishing.* Rochester, NY: Clarellen, 2001.
Livingston, Alan and Isabella Livingston. *Encyclopædia of Graphic Design and Designers.* London and New York: Thames and Hudson, 1992.
Parr, Martin and Gerry Badger. *The Photobook: A History. Volumes I and II.* London and New York: Phaidon Press, 2004 and 2006.
Roth, Andrew. (ed.) *The Book of 101 Books, Seminal Photographic Books of the Twentieth Century.* New York, NY: PPP Editions, 2001.
Rowell, Margit and Deborah Wye. *The Russian Avant Garde Book, 1910-1934.* New York: Museum of Modern Art, 2002.

WEB RESOURCES

Blurb.com/ Print on demand site.
Clarellen.com/ Author's website.
Gaylord.com/ Bookbinding and archival supplies.
LightImpressions.com/ Bookbinding and archival supplies.
Lulu.com/ Print on demand site.
Sharedink.com/ Print on demand site.
Talasonline.com/ Bookbinding and archival supplies.

ACKNOWLEDGEMENTS

As already stated, this book is dedicated to my students. I have always been extraordinary lucky in this regard. Almost without fail I have had wonderful, hard-working and joyous folk with which to work.

I also wish to thank the photographers and/or their estates, who contributed images to the book. The captions acknowledge their individual copyright.

I would like also to thank Nate Larson and Peter Happel Christian for submitting some of their assignments for inclusion in this first edition of the book. I am hoping their example will be followed by other friends and colleagues so that the next edition will be richer and more complex. Further thanks are also extended to Nate who read and critiqued the text. His insightful comments were helpful, and are sincerely appreciated. Additionally, I would also like to thank Bob Rose for proof reading the original manuscript. Additional thanks to Sally Petty, of Visual Studies Workshop, and Barbara Galasso, Rachel Stuhlman and Alana West of George Eastman House.

Finally, I would like to thank all of my photography/art/craft/language/bookmaking teachers for helping me on my way. In particular, I would like to thank my most influential teacher, Nathan Lyons, both for his commitment to the field of photographic education, and his crucial and much appreciated influence on my thinking, writing and image-making.

NOTES

Use the following pages for notes.

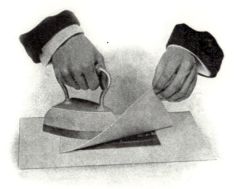

Printed in the United States
216056BV00003B/3/P